JIM CHURCH'S
ESSENTIAL GUIDE TO

COMPOSITION

JIM CHURCH'S
ESSENTIAL GUIDE TO

COMPOSITION

AQUA QUEST PUBLICATIONS, INC. ■ NEW YORK

Library of Congress Cataloging-in-Publication Data

Church, Jim
 Jim Church's essential guide to composition: a simplified approach to taking better underwater pictures / by Jim Church
 p. cm.
 Includes index.
 ISBN 1-881652-18-1 (alk. paper)
 1. Underwater photography—Handbooks, manuals, etc.
 I. Title.
 G525.S514 1998
 910'.9163'4—DC21 97-32170
 CIP

Cover: Cathy Church and John Damron photographed through a porthole at the stern of the *Rhone,* in the British Virgin Islands. I set the f8 aperture for the bluewater background and held the strobe at the f8 strobe-to-subject distance from the porthole. Nikonos III, 15mm lens, single strobe with manual exposure control, Ektachrome 64 EPR (circa 1980).

Page 6: Wayne Hasson deliberately hid one of his model's eyes for this closeup of a diver and lionfish. Hiding one eye is your best way to avoid a cross-eyed stare. Nikonos V, 15mm lens, one strobe with manual exposure control and Ektachrome 64 EPR.

Design by Chris Welch.

Printed in Hong Kong
10 9 8 7 6 5 4 3 2 1

All photos by author unless otherwise credited in the photo captions.

••• ACKNOWLEDGEMENTS •••

I thank the following people for their assistance in preparing this book:

Cathy Church for helping take and posing for many of the photos in the book that were taken early in our careers.

Mike Haber and Mike Mesgleski for providing photos, posing for photos, and for reading rough drafts and offering advice. They spent many long hours discussing the concepts of photo composition with me and provided many of the photographs used to illustrate specific points. Without their help, I may have never finished this work. Michele Haber for proofreading, advising and submitting photographs.

Greg Prian and Randy McMillian for reading rough drafts and offering advice, and Judy Newton for her advice.

The many persons whose pictures are shown, who posed for pictures or whose advice was cited in the text, namely: Lynn Brown (43); Barbara Brundage (79); Bonnie Charles, deceased (116); Cathy Church (front cover model, 29, 46, 49, 63, 65, 88, 112, 115, 116, 120, 121, 122, 123); John Damron (front cover model); Kevin Davidson (17, 54); James Downing (39); Mike Haber (19, 21, 22, 23, 39, 42, 57, 71, 73, 77, 78, 80, 104, 110, 118); Wayne Hasson (6), Kathy Jobin (38); Julie Jordon (64); Theresa Kokesh (61); Linda Kuschel (108); Brian Peterson (15); Jeff & Terri Leicher (97); Angela McCann (90); Mike Mesgleski (28, 31, 42, 43, 49, 52, 55, 57, 58, 61, 86, 91, 94, 107, 108, 109, 118); Susan Obermeir (58); Lisa Scanlon (55); Marty Snyderman (40, 80); Tabby Stone (44); Carol Travorkian (23, 102); Clay Wiseman (40, 80); Jeannie Wiseman (44).

I offer special thanks to the world's most patient publishers, Tony and Josie Bliss of Aqua Quest.

J.C.

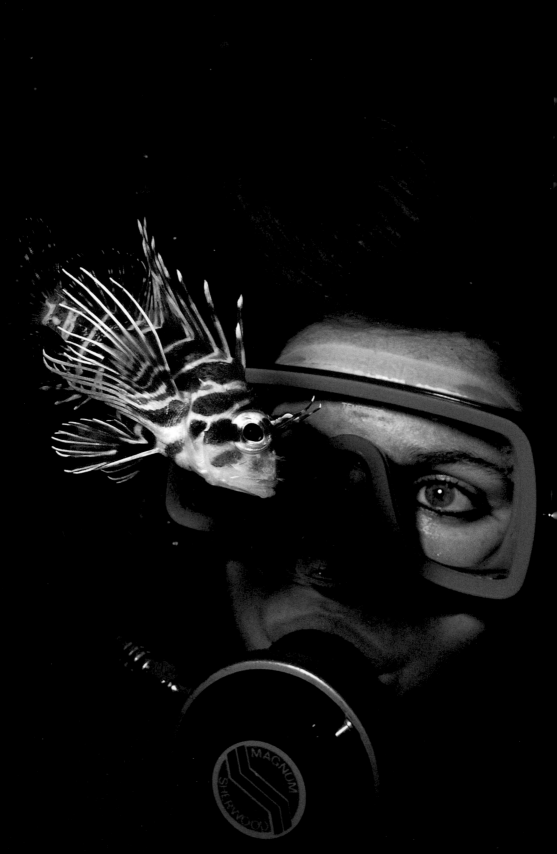

••• CONTENTS •••

PART

1

INTRODUCTION

PART

2

LET'S TAKE A PICTURE

PART

3

LET'S IMPROVE THE PICTURE

P ART
4

APPENDICES

••• FOREWORD •••

Dear Reader,

As you thumb through the pages of this book, you will see that many chapters contain similar pictures, such as wide-angle silhouettes or colorful close-ups. The reason for this duplication is that photographs often contain many different elements of composition. Therefore, because I don't know how to tell you everything at once, I've used different chapters to explain elements of composition, one element at a time.

As the purpose of this book is to strengthen your underwater photo composition, I must assume that you have a working knowledge of the mechanics of underwater photography. If you have a Nikonos V or Nikonos RS, I strongly recommend that you read *Jim Church's Essential Guide to Nikonos Systems* before reading this text. If you are a videographer, I recommend reading *Jim Church's Essential Guide to Underwater Video.*

My Best Wishes,

Jim Church

PART
··· *1* ···

INTRODUCTION

··· 1 ···

PLEASE READ ME FIRST

Composition is an art, not a science. Rules can only take you so far. You will take some of your best pictures when you bend or break rules.

IT WAS SCARY

Writing this book was a scary process because composition is an art, and much of this book is subjective. While we probably agree to the definitions of such terms as shutter speed, you may disagree with some the techniques of composition presented in this book. If so, use this book to help form your own personal techniques for underwater photo composition.

STILLS OR VIDEO

While this book was written for still photographers, most of the ideas presented can also be used by videographers. If you shoot video, ask yourself, "How can I start or end a shot with one of the techniques presented in this book?"

THE MECHANICAL HURDLES

Don't even think about underwater photo composition until you clear two mechanical hurdles: diving skills and basic camera operation. If you are a beginning diver who needs both hands just to dive, master your diving skills first. Then, master the photo-

graphic mechanics of f-stops, shutter speeds, white balance, autofocus, etc., before trying to take a pleasing picture.

THE "NATURAL EYE"

I believe that some photographers, such as Chris Newbert and David Doubilet, have a natural eye for photo composition. The majority of us—*including myself*—don't have a natural eye. However, we can learn to improve our photography by studying basic techniques of composition. Whatever talent we have can be nurtured and developed with study and practice.

●●●
Bryan Peterson, in his excellent book, Learning To See Creatively *(Amphoto), stated: "Don't be misled into thinking that creativity is something for the chosen few—its components can be learned much the same way you learned how to tie your shoes and to dress. . . "*
●●●

DEVELOPING YOUR EYE

Begin by looking at a wide variety of underwater photographs or videos. Decide what pleases your eye and what doesn't. When you see styles that you enjoy, copy them. Copy and practice until you see improvement. You may object to copying and practicing, but why re-invent the wheel? Many techniques of composition were developed centuries ago. Develop a "feel" for some of the tried-and-true techniques first, then develop and expand your own style.

TRY A VIEWFINDER DIVE

I've probably learned more about wide-angle composition during "viewfinder dives" than I have by taking pictures. However, I have rarely been able to persuade photo students to exploit this learning technique. Take a photo dive with nothing but your

15mm or 20mm viewfinder. Look at everything from a variety of distances and angles. The pressure to take a picture is no longer a mind-consuming burden. You will see images in the viewfinder that you have never seen before.

● ● ●

The disadvantage of the viewfinder dive is that you may be angry at me because you couldn't photograph the beautiful views you saw. My answer is: If you had film and were taking pictures, you probably would have never seen these beautiful views. You would have taken the same kinds of pictures you always take. If you don't wish to dive without film, do your viewfinder dive after you finish your roll of film.

● ● ●

How to Pre-visualize Color Slides

Here's a simple way to pre-visualize how contrast will affect a color slide. Look across the room and find a view that has bright areas, such as windows or white walls, and shadow areas, such as the spaces beneath tables and chairs. Squint your eyes, and you will see the shadow areas go dark. This is similar to what happens when you take a picture with color slide film. The highlights remain bright, but the shadow areas tend to go dark.

● ● ●

Your eye will see more brightness and detail in shadow areas than color slide film can record. The exception, of course, is if you use strobe light to illuminate near shadow areas.

● ● ●

When shooting color slides, expose for the highlights and let the shadow areas fall where they may. If, for example, your subject is a diver with light skin and bright accessories, but with a dark BC or dive skin, expose for the light skin and bright accessories. If the dark BC or dive skin blends into a dark background, so be it.

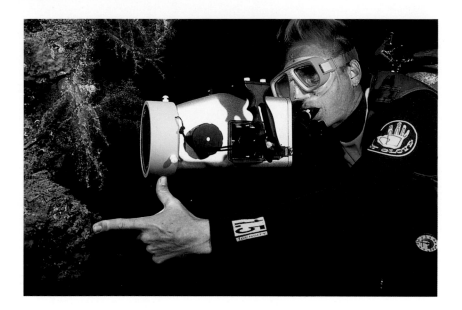

Kevin Davidson uses thumb and fingertip to brace his video camera. Holding a still or video camera steady requires excellent body control. Don't even think about underwater photography until you master basic diving skills. Nikonos RS, 20-35mm zoom lens, twin strobes with manual exposure control and Fujichrome 100 RD.

COLOR EXPECTATION AND ADAPTATION

Color expectation is what you expect to see. *Color adaptation* is how your eye and brain work together to enhance the colors you see.

Color expectation: You know that your dive buddy's diveskin is red, her BC is pink and that the fish she is feeding are yellow. You expect to see these colors in your pictures, but your sunlight color slides are bluish. The reds, pinks and yellows aren't as vivid as they should be! What happened? You expected to see these colors when you took the picture. What we expect to see seems to affect what we think we see.

Color adaptation: To understand how color adaptation

works, hold a blue filter (or piece of transparent cellophane) in front of your right eye (for this example). Close your left eye and stare at a piece of white paper for about fifteen seconds. Take the blue filter away, and your right eye will see the white paper as pink. Because the blue filter introduced a blue cast to your vision, your brain tried to correct the color by adding red. This is color adaptation. Your eye and brain "conspire" to restore lost colors. Once you understand color expectation and color adaptation, you will understand why your pictures are sometimes bluish.

● ● ●
Still photographers use strobe lighting to enhance colors in their color photographs. Videographers use filters, such as the URPro and video lights to enhance colors.
● ● ●

DISTANCE, SHARPNESS AND COLOR

Suspended particles in the water block the camera's view of the subject and reduce picture sharpness. Therefore, the closer you can get to your subject, the sharper the pictures.

Distance is also a key to color and sharpness. Colors are absorbed as light rays pass through water. If you are 50 feet deep, and your subject is 10 feet away, the total light path for sunlight is 60 feet, and the color cast is definitely bluish.

Light from a strobe or video light becomes bluer with distance because colors are absorbed as the light travels to your subject and as it reflects back to your camera. If you want sharp, colorful pictures, get as close as possible to your subject.

● ● ●
It's difficult to photograph sharp details at distances greater than about ten feet, even in gin-clear water. At longer distances, work with forms, shapes and contrast.
● ● ●

··· 2 ···

WHAT ATTRACTS
THE VIEWER'S EYE

Seven key elements that attract the viewer's eye are: (1) brightness, (2) color, (3) contrast, (4) sharpness, (5) eyes, (6) action (real or implied), and (7) humor. The key idea is to have as many of these elements in your subject as possible. If these key elements are largely in the background, the background can draw attention away from the main subject.

BRIGHTNESS

Your eye (the viewer's eye) seeks out brightness when you look at a photograph. The brightness may be the overhead ball of sun, a yellow coney, a bright, reflective dive skin or a multitude of points such as the tips of anemone tentacles. Because your eye usually goes to the brightest part of a picture first, brightness should highlight or silhouette the subject.

Brightness and color pull your eye to Mike Haber's subject, the brittle star hiding inside a sponge. He focused on the brittle star and held his strobe near the sponge's outer body. Canon F1, 50mm macro lens, one strobe with manual exposure control and Ektachrome 64 EPR.

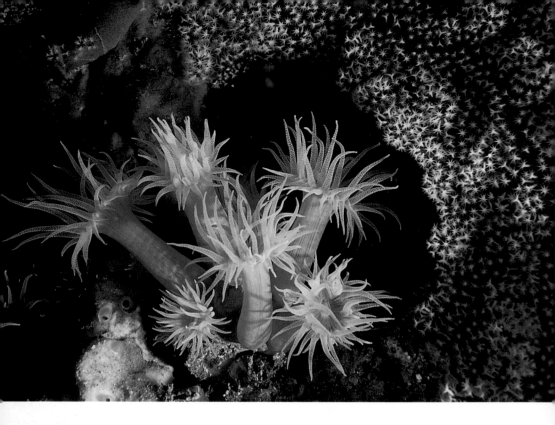

Color, sharpness and contrast are the main elements in this bouquet of cup corals adorning the Fujikawa Maru. *The dark oval in the background provides contrast behind the yellow corals and accents the bright yellow. Nikonos RS, 50mm lens, twin strobes with manual exposure control and Ektachrome 64 EPX.*

COLOR

Color also attracts your eye. Run your eye over the tabloids on a supermarket's rack. Notice how the bright reds and yellows attract your eye. Look at underwater photographs. Notice, again, how often the bright reds and yellows grab your attention. Many cave, tunnel and wreck shots have beautiful shades of blue on blue, but bright, splashy colors often make the picture.

● ● ● —————————————————————————

Because the combination of brightness and color is such a strong eye grabber, make sure your subject is the brightest, most colorful part of the picture. The exception, of course are silhouettes with a bright ball of sun behind the subject.

————————————————————————— ● ● ●

CONTRAST

Contrast is the difference between the darkest and the brightest areas in the picture. Wide-angle silhouettes, backlit with sunlight, are typical examples of composing with contrast. When shooting silhouettes, compose with forms and shapes defined by shades of blue on blue or blue on black. Ignore fine details in shadow areas.

You can select light subjects with dark backgrounds, or dark subjects with light backgrounds, to create contrast. With close-ups, you often have contrast between a brightly illuminated near subject with a dark background or contrasting subject and background colors.

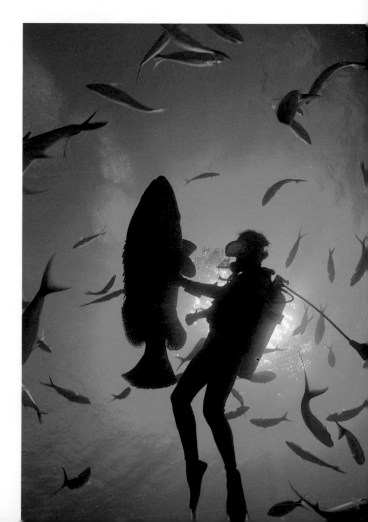

Contrast and action are the key elements in Mike Haber's silhouette shot of a diver and large jewfish. Nikonos V, 15mm lens, sunlight exposure and Ektachrome EPR.

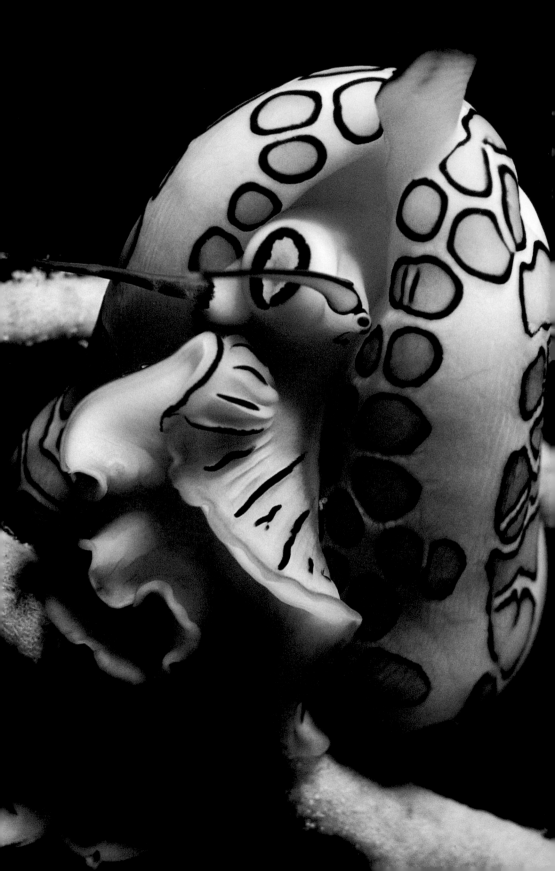

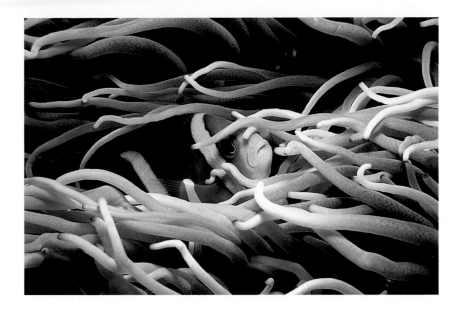

You probably searched for the clownfish's eye as it looks at you from the anemone's tentacles. Carol Travorian took this with a Nikonos V, 35mm lens, Nikonos Close-up Outfit, one strobe with TTL exposure control, and Velvia 50 film.

SHARPNESS

Your eye seeks out sharpness. Thus, your subject should be the sharpest part of the picture (unless you want a special effect). The brightest and most colorful parts of the picture should usually be the sharpest.

EYES

When you view a picture of a living creature, you usually look

The spots on the flamingo tongue emphasize sharpness. The contrast between the colorful subject and the dark background also draws your eye to the flamingo tongue. Growing to about 1.5 inches in length, flamingo tongues are attractive subjects. Mike Haber used a Nikonos V, 35mm lens, 1:1 extension tube, one strobe with manual exposure control and Ektachrome 64 EPR.

for its eyes to establish eye contact. If a diver is looking at something in the picture, you follow his or her line of sight to see what he or she is looking at. If the diver is simply staring at something that is out of the picture, the picture seems to be incomplete. You wonder, what could this diver be looking at. If your model is obviously staring at something, show what that something is. Otherwise, you have an incomplete action.

If a fish's eye is prominent in a fish portrait, focus for the fish's eye. Viewers will accept an out-of-focus tail, but the eye must be sharp.

ACTION, REAL OR IMPLIED

We always look for action, real or implied. At Stingray City, Grand Cayman, the rays swoop over divers in hopes of a free handout of bait fish. At other locations, mantas will swim in loop-the-loop patterns in the beam of your dive light. While action is

Action is the key element as a juvenile French angelfish cleans a larger fish. Because such action is hard to approach closely, it's best to use a telephoto lens. Nikon F4, 105mm AF Micro Nikkor lens, two strobes with manual exposure control and Ektachrome 64 EPX.

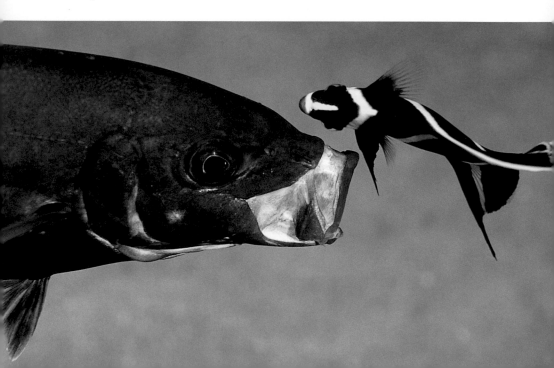

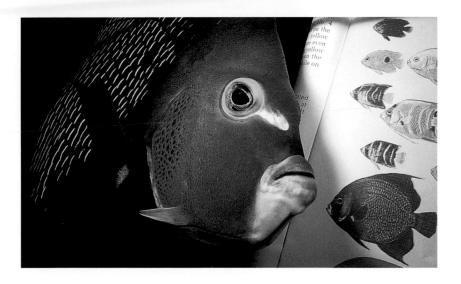

Want to get an angelfish to look at its picture in a book? Try tiny pieces of bait. Nikonos V, 28mm lens, Nikonos Close-up Outfit, one strobe with manual exposure control and Ektachrome 64 EPR.

usually associated with video, you can shoot action shots with a still camera. However, you must learn to anticipate when the peak of the action will occur, or you may miss it.

●●● ————————————————
Implied action leaves something to the viewer's imagination. The big grouper is looking at a diver. Will the diver feed the grouper? Will the barracuda dart out after a fish?
———————————————— ●●●

HUMOR CAN OVERPOWER RULES

If your goal is humor, and your picture or video makes viewers laugh, you've met your goal. Eye-grabbing, belly-laughing humor can overpower other rules and techniques of composition.

●●● ————————————————
Let your imagination run wild. Some tame fish may cooperate for humorous scenes, but don't overlook props, such as rubber sharks or toy dragons.
———————————————— ●●●

⋯ 3 ⋯

LENSES AND PERSPECTIVE

Underwater, your eye sees subjects with about the same perspective as a 35mm lens on a 35mm camera. Thus, the 35mm lens is a normal (standard) lens underwater. A 50mm lens is a normal (standard) lens topside. Lenses with different focal lengths will "see" subjects with different perspectives.

FOCAL LENGTH

Let's keep this simple. The focal length is the number that's included with the name of the lens, such as a Nikonos 35mm lens. (Technically, the focal length is the distance from the optical center of the lens to the film plane.)

Lenses with low focal length numbers are wide-angle lenses. Lenses with high focal length numbers are telephoto lenses.

Some examples of focal lengths for 35mm camera lenses, as used underwater, are:

- 13mm, 15mm and 20mm lenses—Wide-angle
- 28mm lens—Slightly wide-angle
- 35mm lens—Normal (standard) lens underwater (slightly wide-angle, topside)
- 60mm lens—Slightly telephoto

FOCAL LENGTH AND SHUTTER SPEED

How does focal length affect shutter speed? I use the following rule of thumb: If you are extremely steady, the slowest *topside*

hand-held shutter speed will be the speed that approximates the focal length of the lens. With a 35mm or 28mm lens, for example, 1/30 second would be the slowest acceptable shutter speed. With a 105mm lens, 1/125 second is the slowest acceptable speed.

Underwater, it's often harder to hold the camera steady. Thus, the next higher shutter speed is better. As examples, with a 35mm or 28mm lens, 1/60 second would be the slowest shutter speed. With a 15mm lens, 1/30 second is the slowest.

● ● ●

The faster the shutter speed, the sharper the picture. The slower the shutter speed, the blurrier the picture. If you use a strobe, the shutter speed is limited to the fastest speed at which the shutter will synchronize with a strobe. With a Nikonos I, II or III, 1/60 second is the fastest synchronization speed. With a Nikonos IV or V, 1/90 second is the fastest synchronization speed. The Nikon RS synchronizes at 1/125 and some housed cameras synchronize at 1/250 or faster.

● ● ●

DEPTH OF FIELD

Depth of field is the zone of acceptable sharpness in front of the camera, at any focused distance. Depending on the focused distance, about one-third of the depth of field is on the near side of the focused distance, and about two thirds on the far side. The easiest way to visualize depth of field is to get a camera lens and look at the depth of field scale as you change the aperture and focused distance.

Depth of field is determined by picture area and aperture, as follows:

● The wider the angle of the lens (the shorter the focal length and the greater the picture area), the greater the depth of field.
● The farther the focused distance (the greater the picture area), the greater the depth of field with any lens.
● The smaller the aperture (the higher the f-number), the greater the depth of field.

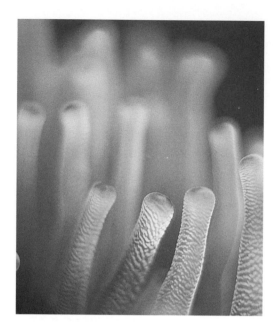

Mike Mesgleski deliberately set the aperture for f2.5 (wide open) rather than f22 for this 1:2 extension tube shot of an anemone's tentacles. The extremely limited depth of field created an artistic effect. At f22, more of the tentacles would have been sharp, and the effect would have been lost. Nikonos V, 35mm lens, 1:2 extension tube, one strobe with manual exposure control and Fujichrome 50.

● ● ●

You can deliberately choose low-numbered f-stops to limit depth of field. This allows you to blur out distracting backgrounds.

● ● ●

WIDE-ANGLE PERSPECTIVE

Wide-angle lenses (such as a 20mm or 15mm lens for a 35mm camera) "see" subjects with wide-angle perspective. Subjects close to the lens appear larger than normal; subjects farther away from the lens appear smaller than normal. This is why a diver's hand reaching toward a wide-angle lens looks so large.

You can use wide-angle perspective to make a fish appear large, when compared to a diver, by composing so the fish is closer to the lens than the diver. If the diver is closer to the lens, even a big fish can appear much smaller than it really was.

● ● ●

Have you ever wondered why the underwater visibility in your wide-angle shots seems to be better than you remembered? The answer is wide-angle perspective. The lens makes the background appear farther away than it really was.

● ● ●

WIDE-ANGLE PERSPECTIVE

Starting at the left, the near fish and the far fish are at different distances from the camera's wide-angle lens. The near fish fills almost all of the picture angle. The far fish fills about one-third.

In the resulting picture (right), the near fish appears much larger than the far fish. This is wide-angle perspective. Wide-angle lenses make near subjects appear larger and closer, and make far subjects appear smaller and farther away.

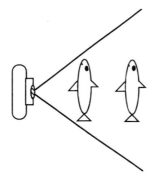

Wide-angle perspective made the near coral appear much larger than the far diver. I placed the Nikonos V camera on its back, beneath the coral. Cathy Church posed above, while looking at her reflection in the dome port. I held the camera at arm's length to reach under the coral and took the picture when Cathy positioned herself over the dome port of my lens. Nikonos V, 15mm lens, weak strobe fill with manual exposure control and Ektachrome 64 EPR.

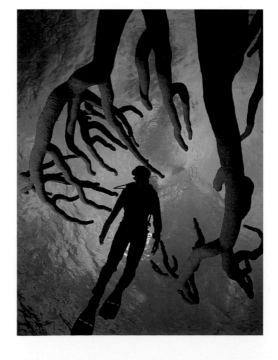

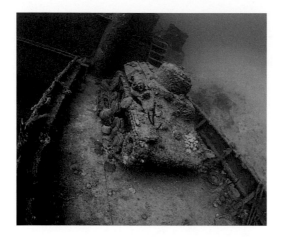

The railings of the cargo hold (left) and the ship's side (right) were actually straight and parallel. However, both of the Nippo Maru's *railings bulge outward in this picture because of the barrel distortion created by my Nikonos RS, 13mm lens, sunlight A (automatic) exposure and Provia 1600 RSP.*

BARREL DISTORTION

Wide-angle lenses produce barrel distortion. Straight, vertical lines at the sides of the picture, and straight horizontal lines at the top and bottom of the picture bulge outward. The wider the lens, the greater the distortion. Thus, you must allow for barrel distortion when choosing camera angles and composing wide-angle pictures with 15mm and wider lenses.

NORMAL PERSPECTIVE

Underwater, a 35mm lens for a 35mm camera has "normal perspective." The 35mm lens "sees" subjects with about the same perspective as your eye. It is best for head-and-shoulder diver portraits at distances from about 2.75 to three feet. In a picture, the relative sizes of divers' heads, hands, bodies, etc. appear to be normal. The 35mm and 28mm lenses are also good for portraits of angelfish and other sea creatures of equivalent or slightly larger sizes.

TELEPHOTO PERSPECTIVE

The perspective of telephoto lenses for 35mm cameras, such

as 100mm or 200mm lenses, is the opposite of wide-angle perspective. The size perspective of near and far subjects is reduced, thus near and far subjects appear to be closer together.

●●● ──────────────────────────────

To understand telephoto perspective, imagine that you are watching a baseball game on television. The image on the screen was taken from behind second base with a telephoto lens. It almost appears that the pitcher and batter could reach out and shake hands.

────────────────────────────── ●●●

Angelfish are ideal subjects for a 35mm or 28mm lens. At locations where fish are accustomed to divers, preset aperture and focus, and stay still. Let the fish come to you. Mike Mesgleski selected an orange elephant ear sponge background and waited until the gray angelfish swam into the scene. Nikonos V, 28mm lens, one strobe with manual exposure control and Velvia 50.

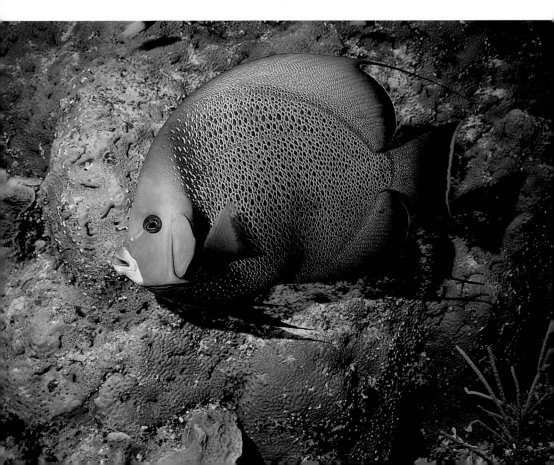

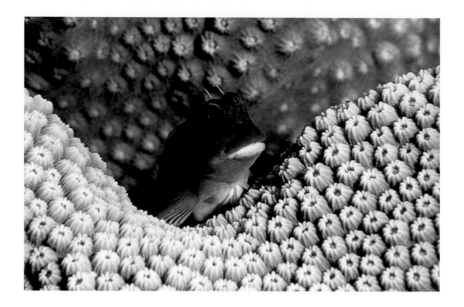

Tiny fish are difficult to approach with close-up framers. Although you can often photograph small fish with a 50mm or 60mm AF Micro Nikkor lens, I used a Nikon F4 and 105mm AF Micro Nikkor lens to photograph this tiny blenny. Notice how the shallow depth of field reduces sharpness in the foreground and background. Nikon F4, 105mm AF Micro Nikkor lens, two strobes with manual exposure control and Ektachrome 64 EPR.

Once you have focused on a subject, a telephoto lens often produces a more normal perspective than a wide-angle lens. Protrusions, such as noses, don't appear larger than normal. Topside photographers often refer to 100mm and 105mm lenses as "portrait lenses" because they don't distort faces.

Part
··· 2 ···
Let's Take
A Picture

··· 4 ···

FINDING UNDERWATER SUBJECTS

A major step in learning underwater photo composition is learning how to find underwater subjects. Think of a restaurant menu; you see what is available before placing your order.

THE EXPLORATORY DIVE

If you don't know anything about the dive site, make an exploratory dive before attempting any serious underwater photography. If you take your camera, use your widest lens. Think of the "big picture." Your goal is to find what photographic opportunities the dive site offers. If you start with macro, you may "miss the forest because you focused on the leaves." I've seen underwater photographers miss fantastic photo opportunities because they stopped and spent their dive with the first subject they found. They didn't look at the "menu" first.

• • •

There are exceptions—some divemasters give excellent briefings, tell you which lens to use and take you directly to their pet subjects. Thus, you might start with macro.

• • •

With some groups, an exploratory dive is impossible because they want a different dive site for each dive. This is fine for explorers, sightseers and snapshot takers, but unfortunate for serious underwater photographers. On my live-aboard dive trips, I often stay 24 hours on each site and sometimes two days at some Truk Lagoon wrecks. My photo students can explore the site,

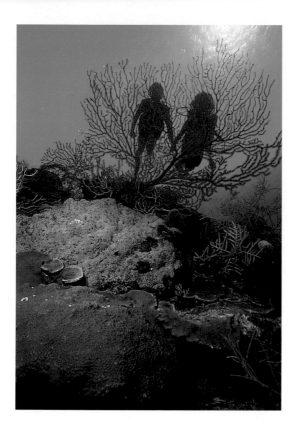

If you can repeat a dive site, start with an exploratory dive to find the strongest features of the site. Choose your goals before going hunting with your camera. Nikonos V, 15mm lens, two strobes with manual exposure control and Fujichrome 100 RDP.

take pictures, and see their processed film. Then, they go back to correct errors, and try different camera and lighting angles.

● ● ●
 Being the only underwater photographer on a trip can be frustrating. If you are serious about taking good underwater pictures, go with a photo-oriented group.
 ● ● ●

HAVING A SINGLE GOAL

Assume that you've made an exploratory dive and will be diving this site two or three more times. For each successive dive, have a definite goal. Will you shoot wide-angle shots of wrecks, medium-angle shots of large fish, or macro shots of tiny critters? Concentrate on one goal at a time and your percentage of good

pictures will increase. If you take a selection of add-on wide-angle adapters and close-up lenses with you, and change lenses constantly, you'll probably end up with snapshots. Your mind is pulled in too many directions, and your pictures will show your lack of mental focus.

● ● ●
The probability of goofing up increases proportionally with the square of the number of goals, times the number of pieces of equipment you use on a photo dive. KISS—keep it super simple.
● ● ●

MANAGING MULTIPLE GOALS

Okay, so you only have one dive and want to do it all. In this case, categorize your goals and work on them one at a time. For example, put on the wide-angle adaptor and shoot a dozen shots of the coral formations, then remove the wide-angle adaptor for a dozen shots of fish. You might end with your close-up lens for eel and fish faces.

● ● ●
If you change goals, stop for a minute. Make whatever mechanical adjustments are needed; but most important, take a minute and change your mind-set. Thinking wide-angle is different than thinking close-ups.
● ● ●

FIND WHAT FITS YOUR LENS

Different lenses do different jobs, which leads us to a rule: Choose a subject that fits your lens, or choose a lens that fits your subject. Some examples of matching lens and subjects are:

- 13mm lens—Large shipwrecks, tunnels or groups of divers
- 15mm lens—Shipwrecks, tunnels, two or more divers
- 20mm lens—Diver portraits, one or two divers waist up
- 28mm lens—Head and shoulder diver portraits, fish

- 35mm lens—Head and shoulder diver portraits, fish
- 60mm lens—Close-ups of fish and marine life
- 105mm lens—Close-ups of subjects that are hard to approach
- Nikonos Close-up Outfit—Small, approachable subjects
- Extension tubes—Extremely small, approachable subjects

Use a lens that allows you to get as close as possible to your subject. The closer the lens to the subject, the sharper and brighter the picture. For example, if you use a 35mm or 28mm lens to photograph a broad scenic view, you will be too far away to take a sharp, colorful picture.

• • •

A young divemaster once beckoned to me to follow him. He led me about 200 yards away from the boat (swimming at 16 knots). He proudly showed me a tiny nudibranch. It was beautiful, but I was using a 15mm wide-angle lens. The nudibranch was pretty, but it didn't fit my lens.

• • •

Find the Strongest Features of the Site

Many dive sites have strong features, such as sharks at Blue Corner, Palau; stingrays at Stingray City, Grand Cayman; or clownfish and artifacts on wrecks in Truk Lagoon. If you want good pictures, concentrate on the strongest features! At Blue Corner shoot the sharks. (Blue Corner is also good for macro because you can almost touch the small fish hiding in nooks and crannies on top of the wall.) At Stingray City shoot the rays. At Truk Lagoon, choose either the fish, corals, or the wide-angle shots of the wrecks. Concentrate on the strongest features the dive site has to offer.

To see what I mean, imagine an underwater photographer who decides ahead of time that he will shoot 1:1 on a new dive site. It doesn't matter what is down there—sharks, rays, fish or a sunken airplane—he will shoot 1:1. When he doesn't find exciting 1:1 subjects, he complains about the "lousy dive site" and wants to move the boat.

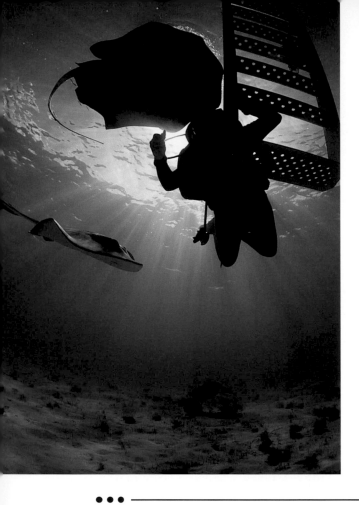

The stingrays are the strongest features of the site at Stingray City, Grand Cayman. I photographed Kathy Jobin at the Cayman Aggressor's *ladder as she interacted with a large ray. Because the picture area was large and close, I chose a wide-angle lens for this sunlight exposure. Nikonos RS, 13mm lens, sunlight A (automatic) exposure and Fujichrome 100 RDP.*

●●●

The "strongest features of the site" can vary for different photographers. Some close-up photographers won't consider going to Truk Lagoon because "they don't like wrecks." However, the abundance of fish and other marine life on the Fujikawa Maru, Shinkoku Maru *and* Sankisan Maru *provide outstanding subjects for close-ups.*

●●●

FIND WHERE IT LIVES

Finding marine creatures is easier if you learn where the creatures live. Look for garden eels in flat, sandy areas. Look for flamingo tongues on sea fans. Look for nudibranchs down in the coral rubble. As previously mentioned, stingrays congregate at Stingray City, Grand Cayman, and sharks glide past Blue Corner, Palau. Squirrelfish hide in openings in coral heads. Clownfish dart around the tentacles of anemones. Once you find a subject

in its territory, approach it slowly. If you go charging in, the fish leaves or hides. Use stealth and patience. Wait until the fish tolerates your presence.

FIND WHAT IT EATS

In some cases, if you can find a critter's food source, you may find the critter. Look for large bites out of sponges which indicate that hawksbill turtles may be nearby. In the Caribbean, look for turtle bites in leathery barrel sponges. Look for nudibranchs feeding on a bryozoan that forms a distinctive reddish crust on rocks. When searching for camouflaged animals, look for traces of their feeding activity, such as grazed trails on rocks.

• • •

At some Grand Cayman dive sites, fish often expect you to furnish lunch. Just the sight of a hand reaching for a BC pocket can interest yellowtail snappers, and the sight of a cheese can will attract dozens of yellowtails and angelfish. Opinions vary regarding feeding the fish. Eels and barracudas could sample a finger along with a handout. Yellowtails sometimes nip your ears. If you feed fish, be careful. I use apple slices to lure angelfish into position because angelfish like apples while yellowtails apparently don't.

• • •

Mike Haber knew that the tiny blennies often hide in openings in sponges, so that's where he looked for his subject. Nikonos V, 1:1 extension tube, one strobe with manual exposure control and Ektachrome 64 EPR.

FIND A CLEANING STATION

Whenever you see a fish behaving oddly—hanging head down, or holding still with its mouth open—you have probably found a cleaning station. Gobies, shrimp and juvenile fish often have territories (cleaning stations) where larger fish go to be cleaned. The fish work on the "honor system." The cleaner eats the parasites living on the fish, and the fish doesn't eat the cleaner (or isn't supposed to). Once you find a cleaning station, move slowly so you don't scare the fish away.

SURPRISE—IT'S HERE

You're cruising along the top of the wall when, suddenly without warning, you see a manta cruising in your direction. Surprise—it's here! If you swim toward the manta at top speed with fins flailing, surprise—it's gone! Stop all unnecessary movement and let the ray maintain its course. It may swim right over you. If so, try not to exhale because your bubbles may startle it. When the ray is at the right distance, take your shots.

● ● ●
*Marty Snyderman and Clay Wiseman (*Guide to Marine Life: Caribbean, Bahamas, Florida; *Aqua Quest Publications) offer this advice: "Mantas make wonderful silhouettes. Try framing the rays directly against the sun with a wide-angle Nikonos 15mm or 20mm lens. Shoot natural light at 1/125 second to freeze the individual rays of sunlight in the sunburst and the manta's action."*
● ● ●

··· 5 ···

THE FIVE BASIC
WIDE-ANGLE SHOTS

*There are five basic wide-angle shots: (1) silhouette,
(2) scenic, (3) portrait, (4) near and far, and (5) close-
up. Use a label maker or laundry marker and plastic tape
to list these basic shots on the back of your camera. Once
you master the five basic shots, you will begin to use them
in combinations.*

THE SILHOUETTE

The silhouette is usually an upward angle shot with a dark
subject against a sunlight background. While strobe light-
ing can accent the foreground, silhouettes rely mostly on forms,
shapes and contrast for their effects. When shooting ambient light
silhouettes, ignore colors and details. Think of shades of blue and
black.

• • •
*Because silhouette subjects are often beyond the effective range
of your strobe, turning the strobe off and setting the shutter speed
dial for A (auto) is often the best exposure technique.*
• • •

THE SCENIC

The scenic is an *establishing shot.* It shows location and visibil-
ity, and prepares the viewer for the slides or video that will follow.
The scenic answers a basic question for non-diving viewers,
"What does it look like underwater?" An upward scenic shot may
show the dive boat above, and divers descending to the bottom.

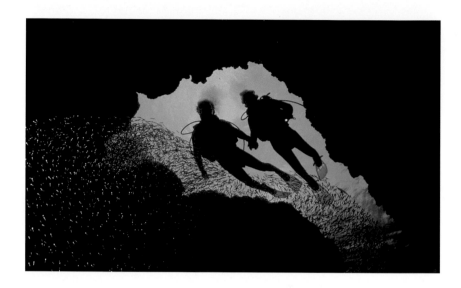

Mike Haber exposed for the midwater background behind the two silhouetted divers, but used one wide-beam strobe with diffuser to accent the schooling silversides in the foreground. Nikonos V, 15mm lens, manual exposure control and Ektachrome 64 EPR.

A scenic doesn't always cover a vast area. A trumpetfish adds a point of interest to Mike Mesgleski's reef scenic. Nikonos V, 15mm lens, one strobe with manual exposure control and Ektachrome 64 EPR.

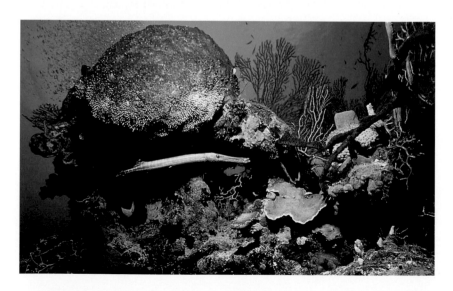

A downward scenic shot may show divers on the reef, or the topside of a sunken vessel. Strobe lighting is usually used for the foreground and sunlight for the background exposure.

● ● ●

Meter for the background to determine the aperture, and use manual or TTL strobe lighting to add color and detail to the foreground. Because the Nikonos RS and some housed cameras with matrix flash fill sometimes overexpose, I set the exposure compensation dial for minus one-third stop underexposure.

● ● ●

THE PORTRAIT

Portraits often feature divers, or divers interacting with marine life. For good color, brightness and sharp details, shoot portraits closer than three feet. Portraits don't always have to be of people, fish, sharks, rays or other living creatures. You can also take portraits of non-living subjects, such as the artifacts on sunken

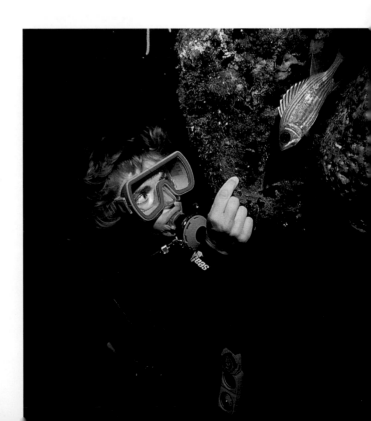

Using a Nikon SB-103 strobe held in close and set for full-power, Mike Mesgleski was able to use a small enough aperture to underexpose the midwater background behind Lynn Brown. Nikonos V, 15mm lens, one strobe with manual exposure control and Ektachrome 64 EPR.

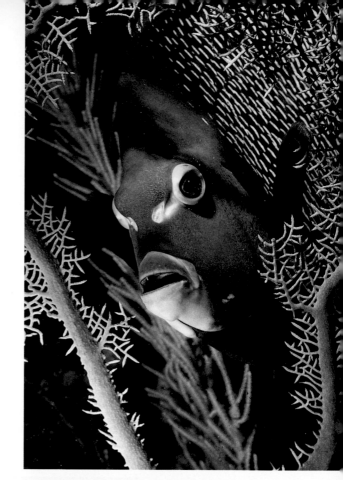

Tabby Stone worked hard to make his angelfish close-up portrait look different. He used an apple slice to entice the fish to peek through the fan. The dark background emphasizes the near subject. Nikonos IV-A, 28mm lens, Nikonos Close-up Outfit, two strobes with manual exposure control and Ektachrome 100 EPP.

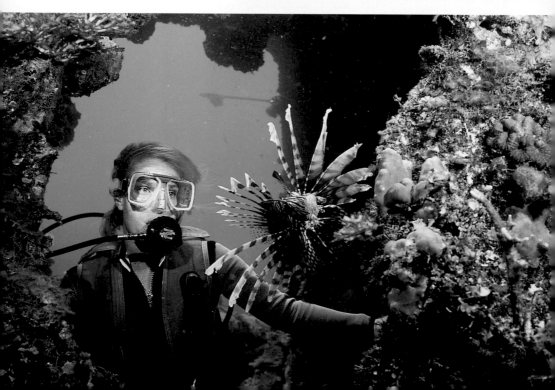

ships. To emphasize close-up portrait subjects, underexpose the background and use strobe lighting to highlight your main subject.

● ● ●
Get close, get close, get close! If the distance looks good to your naked eye, cut the distance in half if you are using a 15mm lens. If you try to take diver portraits at distances greater than three or four feet, your subject is often in the "blah zone" discussed below.
● ● ●

Avoid the Blah Zone

The *blah zone* is a distance range in which it is difficult to take a sharp, colorful picture. Just enough strobe light strikes the subject to show some color and detail, but the subject is too far away for a sharp picture. In Caribbean waters, the blah zone begins approximately four feet in front of your camera and extends to the range of your strobe. Subjects lose details and color in this zone. The exact limits for the blah zone are highly subjective. It depends on water conditions, the power of your strobe and how much image degradation you will accept.

● ● ●
If you shoot a portrait at three feet or closer, the subject will appear sharp and colorful. However, if you shoot at a longer distance—say four to eight feet—there will be just enough strobe light to partially illuminate the diver, but you are too far away for good sharpness and color. Beyond about eight feet, so much sharpness and color are lost that you should consider shooting a silhouette rather than a portrait. To sum up, your best diver shots are taken either up close or as distant diver silhouettes.
● ● ●

Notice how the lionfish is sharper than Jeannie Wiseman's face. Jeannie is at the edge of the "blah zone." I should have posed her closer. Nikonos RS, 20-35mm zoom lens, two strobes with manual exposure control and Fujichrome 100 RDP.

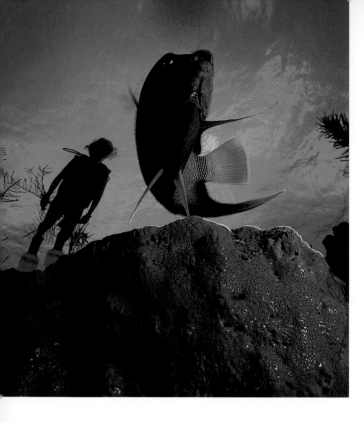

I used a small mirror to lure the queen angel near the elephant ear sponge while Cathy Church posed as a distant diver. As with other near and far pictures, the aperture was set for the blue-water background, and the strobe-to-subject distance was set for the near fish and sponge. Nikonos V, 15mm lens, one strobe with manual exposure control and Ektachrome 64 EPR.

THE NEAR AND FAR

The near and far shot has two main subject areas: a near subject illuminated with strobe light, and a far subject or background illuminated with sunlight. Having a bright, colorful elephant ear sponge in the foreground and a distant diver in sunlight silhouette is a common example. In this situation, the f-stop is determined by the distant background, and the strobe is held at the corresponding distance from the near sponge. The goal is to balance the strobe light and sunlight.

● ● ● ──────────────────────────────────

The near and far technique simulates depth in your pictures. Although the pictures are flat, the viewer perceives the bright, colorful near subjects as being close, and the distant sunlit subjects as being farther away.

────────────────────────────────── ● ● ●

WIDE-ANGLE BACKGROUND PROBLEMS

Have you ever seen wide-angle pictures with awkward divers

in the background? This happens when you get *subject fixation.* Your eyes and attention are on your near subject, and you don't notice what's happening in the background or in the corners of the picture. Before putting the viewfinder to your eye, scan the scene for potential background problems.

● ● ●

When composing wide-angle backgrounds, look at all four corners of the picture in the viewfinder before taking the picture. Look for fins, heads or other clutter at the edges of the picture area. Fill the viewfinder with subject from corner-to-corner. Compose in the viewfinder, not with your naked eye!

● ● ●

THE WIDE-ANGLE CLOSE-UP

Wide-angle close-ups are taken with wide-angle lenses at distances of about 1.5 feet or less. With a Nikonos 20mm lens, the

The shrimp was about six inches from the dome port of my 15mm lens when I took this wide-angle close-up portrait. Nikonos III, 15mm lens, one strobe with manual exposure control and Fujichrome 100.

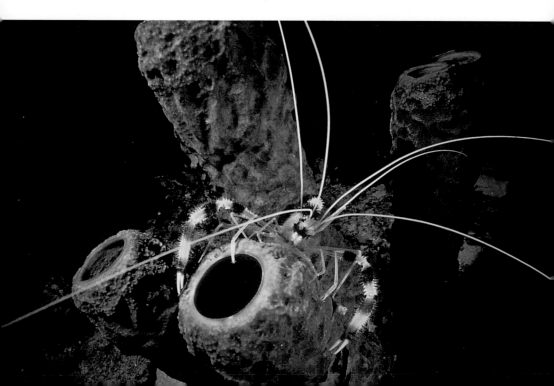

minimum focused distance is about 1.3 feet; with the 15mm lens, the minimum is about six inches from the dome port; and with the RS 13mm lens, the minimum is about 3.5 inches from the dome port. The f-stop is based on close-up strobe-to-subject distances.

● ● ●

With a Nikonos 15mm or 20mm lens, try wide-angle close-ups at night. Remove the viewfinder, set for minimum focus, and preset shutter speed and aperture. To aim, hold the camera about eight inches in front of your face and pretend that you are looking through the camera back.

● ● ●

COMBINATIONS

While I divided wide-angle shots into discrete categories, you will learn to use them in combinations. The silhouette, for example, can be combined with the scenic, and the portrait with the wide-angle close-up. The combinations are limited only by your imagination.

THE JIM CHURCH WIDE-ANGLE FORMULA

Make a procedure list (formula) and follow it. This frees your mind for creative thought. My list follows. As you gain experience, you can modify it or develop your own.

1. Subject—Find a subject that fits your lens.
2. Technique—Choose silhouette, scenic, portrait, near and far, or wide-angle close-up.
3. Camera angle—Choose a camera angle that presents the desired view of your subject.
4. Lighting—Set the aperture for the main light source, sunlight or strobe. If you are shooting a near and far, check your strobe exposure table to balance strobe and sunlight.

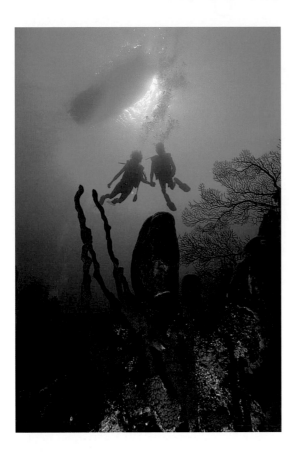

A combination of silhouette, scenic, and near and far, blend to form this picture. The two divers, Cathy Church and Mike Mesgleski, and the boat are in silhouette. The overall view is a scenic. The near and far includes the near sponge and distant divers and boat. Nikonos V, 15mm lens, one strobe with manual exposure control and Ektachrome 64 EPR.

5. Background—Check the background for awkward divers or other clutter.
6. Pose your model—If you are working with a model, fine-tune the pose.
7. Fill the viewfinder—Fill all four corners of the viewfinder, not just the center.
8. Focus and take the picture.

● ● ● ─────────────────────────────

How much detail you should include at the top, bottom and sides of the picture, is a hard decision. If you have the time and film, bracket with picture area. If not, my rule of thumb is: if in doubt, leave it out. Shoot tight and minimize camera-to-subject distance.

───────────────────────────── ● ● ●

··· 6 ···

SHOOTING DIVERS AIN'T EASY

If you want pleasing, well-composed pictures of divers, you must accept this fact of life: Shooting divers ain't easy. Their noses squish against their masks, their gear is often raggedy, they often stare at your camera lens, and they often turn away and show you their tanks and fins. That is, if they aren't waving at you or making faces at the camera.

SHOOTING THE GREAT UNPLANNED

You've seen the photographer (it might be you) who waits until the last minute to assemble his camera system. As the divemaster gives the briefing, and other divers listen and make their plans, he is fussing over focus rings or ISO settings. When he gets into the water, he can't find anybody or anything. He surfaces and yells to the boat, "Where is everybody? Where is the dive site?" The answer is simple: They went that-a-way. This is a typical example of poor planning.

● ● ●
Get your camera gear assembled ahead of time. Listen to the dive brief carefully. Find out where the other divers will go and try to get there first. Then, photograph them as they approach.
● ● ●

WHAT WILL THE DIVERS DO

Find out what the other divers intend to do after they enter the water. If they plan to explore ten acres of reef, you're in trouble.

If they have a definite destination, such as a cleaning station, get there first so you photograph them as they approach. Otherwise, you will end up with pictures of their fins and tank bottoms.

Fish feeding is an accepted pastime at some dive locations, and divers feeding fish can lead to interesting pictures. Feeding the fish also helps you control the action because the divers and fish usually tend to stay at one place for a while.

● ● ● ────────────────────────────────

Don't expect inexperienced, sightseeing divers to pose for you. Regardless of what they promise before the dive, their brains turn to aqua-mush once they submerge. Even with experienced divers who agree to pose for you, the probability of good pictures declines with the complexity of your shooting plan. KISS—keep it super simple.

──────────────────────────────── ● ● ●

It's hard to do professional work with new, excited divers, unless you want some comic relief. Nikonos II, 28mm lens, single strobe with manual exposure control and Ektachrome X (circa, 1969).

Finding the right place to take the picture is the foundation for good diver pictures. In this case, the only strong feature of the site was the big barrel sponge next to a soft coral. Mike Mesgleski, a model with ESP, moved in automatically and I got the shot. Nikonos V, 15mm lens, two strobes with manual exposure control and Fujichrome 100 RD.

FIND A SCENE (BACKGROUND) FIRST

●●● ──────────────────────────────

For the balance of this chapter, assume that you have some control and will receive at least some cooperation from your diver models. However, unless you are signing paychecks, don't bet your life on receiving cooperation.

────────────────────────────── ●●●

One of the hardest tasks you'll face when shooting planned diver shots is finding a location—finding a background or foreground that will enhance your diver picture. At a new dive site, start with the exploratory dive discussed in Chapter 4. If your models don't wish to follow you on every dive, let them go elsewhere as you search for picture-taking places. This also gives them some freedom away from your camera.

• • •

When searching for places to take pictures, I sometimes scout with a video camera. I don't try to shoot good video, I just document potential picture-taking places. Once the scenes are on tape, I can play the tape for the models and freeze frame as we discuss poses.

• • •

Look for sand patches near coral formations. You can position your models on the sand, near the coral, without touching the coral. Avoid placing your models where they can damage marine life.

• • •

How do experienced photo pros at resorts and on live-aboard dive boats take so many flattering pictures of guests in such a short time? It's simple: They already have the best picture-taking places in mind and know how to pose people at these places without damaging anything.

• • •

The profusion of fans and sponges on a Caribbean wall can be overwhelming when you look for a place to take your picture. Look for a single strong feature. Find something jutting out from the wall, such as a set of sponges, with which you can pose your model. Look for coral formations, crevices or tunnel openings that you can use to frame divers. Just make sure that your models aren't clutching the wall. If they must hold on, tell them to use a thumb and first finger to hold a rock or dead area.

PLACE THE DIVER IN THE SCENE

Once you have one or more picture-taking places in mind, it's time to discuss the poses with your model(s). If you have the scene on video, play it first. Then, make simple stick figure sketches to show the model what you want them to do.

Underwater, try aiming the camera at the background and then letting the model look through the viewfinder. It's much easier for a model to relate to the scene after they've seen it in your wide-angle viewfinder.

Finding the right place to take the picture is the foundation for good diver photos. Kevin Davidson led me to one of his favorite picture places, between the port lifeboat davits of the Fujikawa Maru. *Once there, it was my job to place him in the scene. Nikonos RS, AF 20-35mm zoom lens, two strobes with manual exposure control and Fujichrome 100 RDP.*

Give your models something to do if you want to show an interesting action. For example, Mike Mesgleski, Lisa Scanlan and "Sweet Lips" play with their hula hoop. Nikonos V, 15mm lens, two strobes with manual exposure control and Fujichrome 100 RD.

GIVE MODELS SOMETHING TO DO

Whenever possible, give your models something to do. They can be feeding fish, taking pictures or examining artifacts. As long as the models are occupied with some task or action, their actions will appear natural. This helps you avoid stilted poses.

USE OBVIOUS HAND SIGNALS

Discuss and demonstrate hand signals ahead of time. Keep the signals simple and direct. Always signal positively (what you want the model to do), not negatively (what you don't want the model

to do). Give one signal at a time. I use my forearm and fist as a basic signaling tool. My forearm represents the model's body and my fist represents the model's head. By holding my forearm at different angles, I can signal the desired body positions to the model.

● ● ●

Models often don't know where to look, so they stare at you with a confused expression. Tap your mask with two fingers, then point to the object or direction where you want the model to look. If you want the model to look past you, tap your mask and point over your shoulder.

● ● ●

Make Eye Contact, Nod and Shoot

Once the model is in position, and you have checked your camera settings, make eye contact with the model. Each of you should nod your head to signal that you are ready. After the nods, take the picture. Have a signal for "I am through shooting." Otherwise, models may think that you are finished shooting before you are. (I use a palm down, side to side waving motion.)

● ● ●

If the model's eyes will appear in the picture, the model should glance at the camera lens to verify that the lens can see his or her eyes. Then, the model should switch their gaze to the desired subject area before nodding.

● ● ●

Don't stop with one picture. Take at least three bracketed exposures. If you are good at estimating exposure settings, bracket in one-third or one-half stops. If you have time, bracket with different camera angles and vertical and horizontal formats. A variety of different views may be valuable later.

● ● ●

To signal "let's repeat the last action or picture," point a first finger up above your head and move it in a circular motion. (I call this, "Play it again, Sam.")

● ● ●

Individual Distance

Most living, breathing and thinking creatures (you, me and most fish) have an *individual distance*. This is the minimum distance at which we feel comfortable when we are with others. With strangers, our individual distance may be three or four feet. With acquaintances, it might be two or three feet. With close friends, it might be one foot or less. For underwater photographers, individual distance is a constant problem. You will be continually signaling your models to get closer, get closer and get closer.

● ● ●

When posing, models must get closer to each other than they normally would topside. To inexperienced models, your constant "get closer" signals are confusing and irritating. You are telling them to get closer than they think they should be. Emphasize the importance of getting close ahead of time.

● ● ●

Hold Objects Close

If a model is holding an empty shell and is either looking at the shell or showing it to you and your camera, tell him or her to hold the shell no more than six inches from their face.

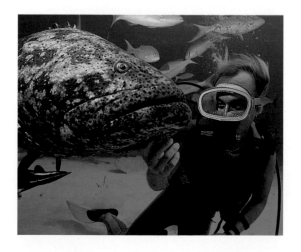

Mike Haber signaled Mike Mesgleski to move in close to "Sweetlip's" face. An experienced model, Mike quickly moved in. Nikonos IV-A, 15mm lens, one strobe with manual exposure control and Ektachrome 64 EPR.

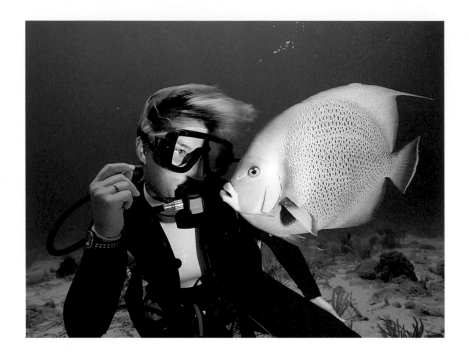

Susan Obermeier's left eye can't be seen. This avoids the possibility of a cross-eyed look at the near gray angelfish. Mike Mesgleski took this portrait with a Nikonos V, 15mm lens, single strobe with manual exposure control and Ektachrome EPP.

● ● ●
Persuading inexperienced models to hold objects close will be a constant battle because people tend to hold objects one or two feet from their faces. Make sure that you discuss holding objects close ahead of time and have a simple hand signal.
● ● ●

HIDE ONE EYE

If the diver is looking at something close to their face, they tend to look cross-eyed. A few models can focus their eyes past the near object, but most can't. In this case, my favorite technique is to compose the shot so one of the model's eyes is hidden.

I signaled Susan Pagey and Mike Mesgleski to get closer together, angle their bodies toward me and to show my camera what they were looking at. Nikonos V, 15mm lens, twin strobes with manual exposure control and Fujichrome 100 RD.

LET THE CAMERA SEE THE ACTION

If a model is showing something to the camera, the camera must see the most important view of the subject. If two divers are communicating, have them angle their bodies so the camera sees a three-quarter view of their faces. Don't pose them facing each other, even though this seems normal to them.

··· 7 ···

A Quickie Guide to Modeling

The photographer makes confusing hand signals and dozens of thumb and first finger O.K. signs. Just what does the O.K. signal mean? O.K. to stop posing, O.K. to pose again, or O.K. I'm going to take a picture. . .

A Chimp Could Take the Picture

From the model's viewpoint, being a model is harder than being a photographer. As I heard one model say (after posing for her photographer spouse), "A chimp could take the picture."

··· ———————————————————————————

To underwater photographers who disagree with the "chimp" theory, let me pose two questions: Have you ever tried to take magazine-quality photos with inexperienced models? Have you ever tried to model? Lot's of luck, Buster. Enjoy your snapshots.

——————————————————————————— ···

When modeling, it's not working hard that counts, it's working smart. You need to learn the basic techniques.

Dress for the Part

Several years ago, I wrote an article about night photography for a major diving magazine. The article barely made the printer's deadline and was published. However, I received a scathing letter from the publisher. My two models demonstrated all the correct

diving and photographic techniques, but were dressed shabbily. Had the magazine not reserved the space until the last minute, the article would have been rejected.

● ● ●
─────────────────────────────

If you're going to model, dress for the part. Color-coordinated dive gear is important. Avoid dive masks that give you a bug-eyed appearance, and don't festoon yourself with gear that dangles below you.

─────────────────────────────
● ● ●

Diving gear can sometimes be too bright and colorful, especially if florescent. The colored light reflected from colorful, florescent fins, for example, gives a color cast to the suspended particles in the water around the fins. I wish dive gear manufacturers would eventually learn this and offer "photo-friendly"

Model Theresa Kokesh dressed in colorful dive gear when she posed for Mike Mesgleski. Nikonos V, 15mm lens, one strobe with manual exposure control and Fujichrome 100.

colors. Personally, I like light colors with subdued contrast between basic gear, accessories and trim.

Bare, light-skinned hands can be a problem if the model is wearing a dark suit. If you expose for the light hands, the dark suit could merge with a dark background. Try color-coordinated gloves that are slightly lighter than the suit.

Female models shouldn't overdo make-up. Use just enough eye make-up so your eyes can be seen behind the mask. To avoid looking like an underwater zebra, choose water-resistant make-up that won't run when wet.

SWIM INTO THE CURRENT

After years of being the photographer, I was thrust into the role of model. The photographer placed me in position with hand signals, but before she could take the picture I was out of position. After several attempts, I realized that I was posing with my body heading in the same direction as the current. Not being blessed with the ability to swim backwards gracefully, I couldn't hold my assigned position.

• • •

If the pose requires to you face with the current, try the "circle around" technique. Glide in with the current, then circle around and glide in again. Don't try to hold one position.

• • •

When posing against the current, swim gently into the current. Your body will have a natural appearance, and you can maintain your position in the scene. It's best if the photographer and model discuss this ahead of time.

ALIGN LIKE A TRUMPETFISH

If the chimp (the photographer) isn't giving you instructions, align yourself with any leading lines you see in the background. Pretend that you are a trumpetfish. If the photographer crosses his wrists as a signal to shift to the *discovery pose*, as discussed in Chapter 11, align yourself so you cross the main leading line.

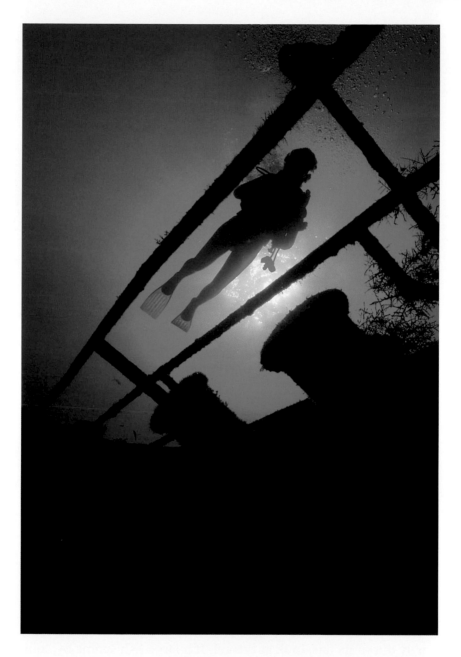

Unless the photographer signals differently, align your body with strong leading lines. In this shot, Cathy Church aligns herself with the railing of a sunken wreck. Nikonos III, 15mm lens, sunlight exposure and Fujichrome 100.

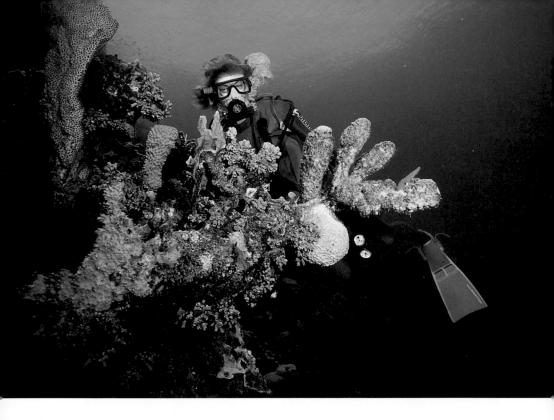

Julie Jordon poses at an angle opposite to the angle of the outcropping of coral and sponge. She is using the discovery pose, *which is explained in Chapter 11. Nikonos V, 15mm lens, one strobe with manual exposure control and Ektachrome 64 EPR.*

POSE AT ANGLES

Don't pose with your body straight up and down, straight on, straight away or straight across unless the photographer insists that you do. Position yourself at an angle to the camera.

WHERE TO LOOK

Look at the strongest object or action in the scene. If an eel is partly out of its lair, look at the eel. If a large fish swims by, look at the fish.

For portraits, the rules may change. If the portrait is for non-divers, and there are no strong objects or actions in the picture,

look over the photographer's shoulder. If the portrait is personal for a loved one, look at the camera lens so the viewer can make eye contact with you in the picture.

Keep it Tight

Because minimizing the distance between you and the camera is important for color and details, tighten up the pose. If you are holding a shell and looking at it, hold it a few inches from your face. If you are showing something to the photographer, hold the object close to your body, not at arm's length.

Because eye contact between diver and eel was important for this shot, Cathy Church raised her arm to an uncomfortable position. She glanced at the camera lens (to make sure the lens could see her eyes). We exchanged nods, she looked back at the eel and I took the shot. Nikonos V, 15mm lens, single strobe with manual exposure control and Ektachrome 64 EPR.

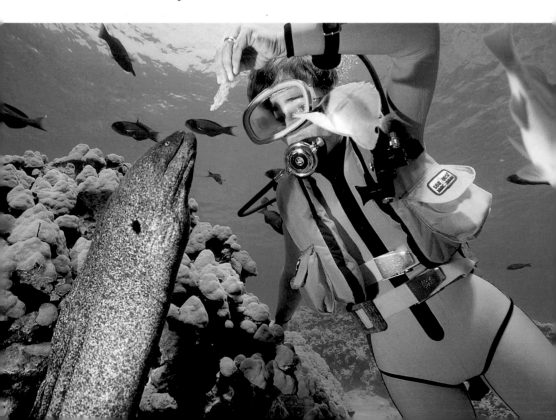

REMEMBER TO SMILE

When you get involved with a pose or action, your face often shows a strained expression. (This is especially true if you are cold, tired, bored, confused or angry at the photographer for being so damn slow.) Thus, remember to smile. Smiling may be difficult when wearing a facemask, so you may have to try harder.

ASK ABOUT BUBBLES

Some photographers want bubbles in the picture, others don't. Ask ahead of time. If the photographer wants bubbles, try to position your head so the bubbles don't cover your face.

··· 8 ···

COMPOSING CLOSE-UPS

Shooting close-ups is deceptively easy. I could teach a chimp to shoot close-ups if you could teach it to dive. Composing close-ups that are pleasing to view, however, is an entirely different matter.

THE "JIM CHURCH CLOSE-UP FORMULA"

Before getting to composition, let me give you my four-step formula for shooting close-ups. It doesn't matter if you have a Nikonos with close-up lens or extension tube, housed SLR (single-lens reflex) camera or a Nikonos RS. Use a laundry marker and plastic tape to attach the words, *distance, f-stop, angle and shoot*, to the camera back. These words and their meanings are as follows:

1. Distance—Determine the camera-to-subject distance. With framers, distance is preset. With a Nikonos RS or housed camera, decide on a basic distance. You will fine-tune focus just before you shoot.
2. F-stop—Determine your f-stop from your strobe exposure table for the strobe-to-subject distance used.
3. Angle—Adjust the strobe arm for the desired strobe angle.
4. Shoot—Take the picture. If you have SLR focusing, adjust focus just before shooting.

You must do each of the above steps every time you change your camera-to-subject distance.

··· —————————————————————

I encourage students to silently chant: "distance, f-stop, angle, shoot," each time they change camera-to-subject distance. Sound's silly, but it works.

——————————————————— ···

Simplicity, color and sharpness are the key elements in this picture of a tiny goby on a yellow tube sponge. Nikonos RS, 50mm lens, two strobes with TTL exposure and Fujichrome 100 RDP.

SIMPLICITY, COLOR AND SHARPNESS WINS

Having seen (and judged) numerous underwater photography contests, I can assure you that simplicity, color and sharpness often wins. As I said in Chapter 2, glance at the tabloids on the supermarket rack. See how the reds and yellows grab your eye. Bright colors attract attention!

THE CLOSE-UP PORTRAIT

Good close-up shots often feature a single subject, such as a fish, eel's face, tube worm or hermit crab. For California divers, a curved frond of kelp is a classic subject that has won many contests. If you opt for a single portrait subject, make sure the subject overpowers the background. (Unless, of course, the

background is an important part of your picture.)

Once you've selected a single subject, ask yourself, "How can I make this subject appear different?" Photo contest judges have often seen hundreds of angelfish pictures and want to see a new approach. Experiment with different backgrounds, angles and lighting. Try to tug at the judges' emotions—a cute little fish with a delightful smile may appeal to them.

THE FLOWER ARRANGEMENT

If your picture will feature multiple subjects, such as a grouping of tube worms, think of these subjects as a bouquet of flowers. Look for an angle that gives you a pleasing "flower arrangement."

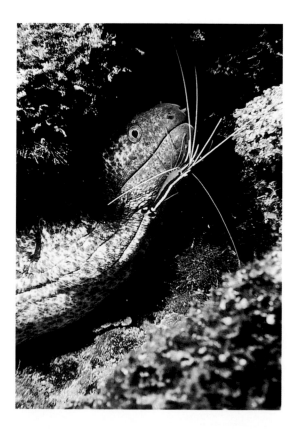

An eel being cleaned by a scarlet lady shrimp. Rolleiflex in Rolleimarin housing, 120 film format, #2 close-up lens, Press 25B flashbulb and Ektachrome-X (circa, 1969).

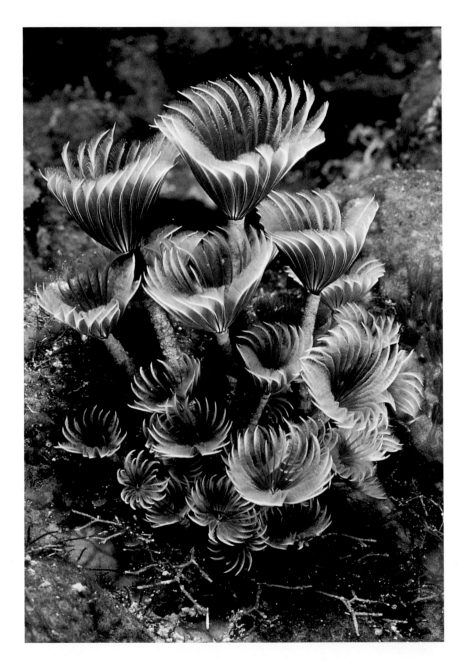

Appearing as a bouquet of flowers, these fan worms were just begging to have their picture taken. Nikonos V, 35mm lens, Nikonos Close-up Outfit, one strobe with manual exposure control and Ektachrome 64, EPR.

● ● ●

The next time you visit a flower shop, take a few minutes to study the arrangements of the different bouquets. Notice how often there will be one or two dominant flowers in each grouping. If there are no dominant flowers, look at the patterns of arrangement and colors.

● ● ●

USING DARK BACKGROUNDS

A dark background emphasizes a near subject. The viewer knows what to look at. However, the subject must stand on its own merits because the background is only a stage, and your strobe lighting is the spotlight.

Mike Haber chose to photograph this Christmas tree worm with a darkened background. Nikonos IV-A, 35mm lens, 1:1 extension tube, one strobe with manual exposure control and Ektachrome 64 EPR.

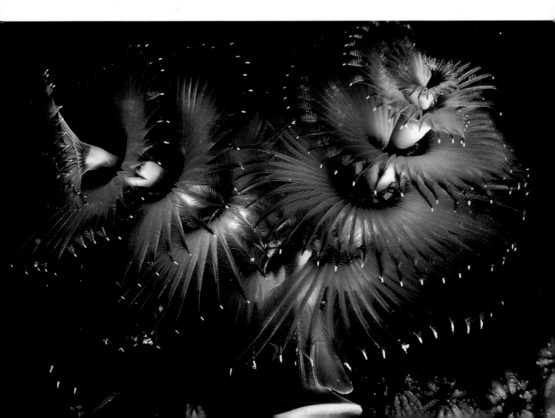

● ● ● ────────────────────────────────

When you are shooting close-ups with extension tubes or macro lenses, for example, you can darken a background by angling the camera so midwater appears behind the subject.

──────────────────────────────── ● ● ●

USING LIGHT BACKGROUNDS

A light, midwater background directs the viewer's eye to the main subject. A light coral or sand background may become part of the subject. Imagine, for example, a tiny fish peeking out from colorful corals. The background adds color and documents where the creature lives. If an octopus is changing colors to match its background, the background becomes part of the picture because it helps show behavior.

A light background shows the tiny octopus's territory as it plays "tug of war" with a diver. Nikonos RS, 50mm, two strobes with TTL exposure control and Lumiere 100 LPZ.

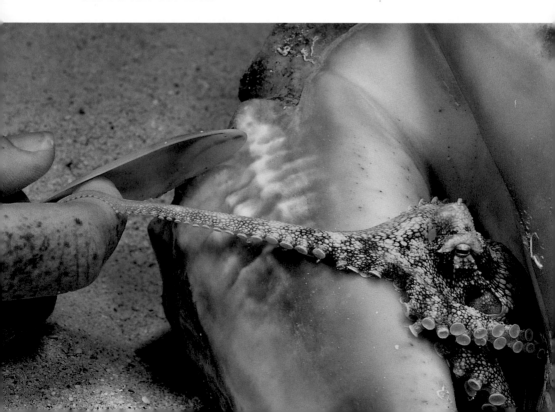

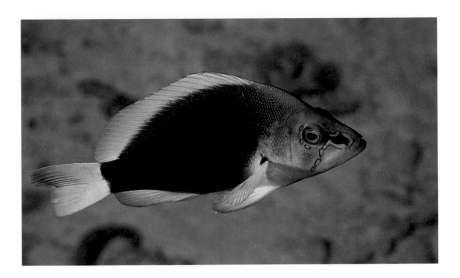

Limited close-up depth of field will blur distracting backgrounds. Mike Haber shot this shy hamlet with a housed Canon F1, 50mm macro lens, one strobe with manual exposure control and Ektachrome 64 EPR.

TELEPHOTO BACKGROUNDS

When you use SLR viewfinding, the image you see in the viewfinder will be at the widest aperture. When you take the picture, the lens closes down to the selected aperture which might be f8 or f11. Because you see very little depth of field in the viewfinder, you may not realize that something behind the subject is also in the picture.

• • •
When shooting SLR telephoto close-ups, look over the top of the housing and scan the background. Make sure that there are no competing forms or shapes behind your subject. Also, avoid color on color mergers between subject and background. • • •

DEPTH OF FIELD AND THE BACKGROUND

You can de-emphasize cluttered backgrounds by reducing

depth of field, and you can emphasize background sharpness by increasing depth of field.

1. To blur the background: focus on the nearest part of the subject and use lower-numbered f-stops.
2. To maximize background sharpness: focus about one-third past the nearest part of the subject and use higher-numbered f-stops.

SIDE LIGHTING FOR TEXTURE

Side lighting avoids the flat appearance of front-lit subjects by highlighting textures. Strobe light skims over the "hills and valleys" of the subject's surface and emphasizes frilly, intricate patterns, and creates and emphasizes shadow details.

I illuminated the nautilus with two strobes, from the extreme left and right sides, to backlight and emphasize the texture of the sea fan, and to accent the ridges in the nautilus's shell. Nikonos RS, 20-35mm zoom lens, two strobes with manual exposure control and Fujichrome 50 RF.

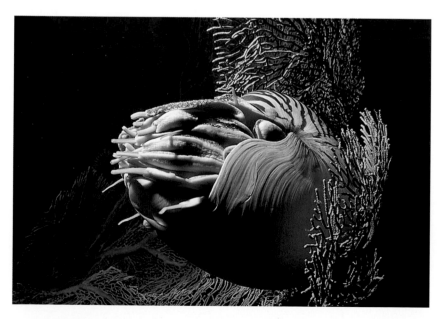

Move slowly and carefully, and you may be able to place your extension tube framer for a shot of a stonefish's eye. Nikonos V, 35mm lens, Nikonos Close-up Outfit, two strobes with TTL exposure control and Ektachrome 64, EPX.

BE CAREFUL WITH FRAMERS

Fragile creatures, such as arrow crabs, hermit crabs and nudibranchs, as well as octopus eyes and soft corals are easily damaged. Be careful with your framer—impulsive underwater photographers sometimes injure or destroy their subjects.

··· 9 ···

WHEN DO YOU
TAKE THE PICTURE

There is a "Kodak Moment," the perfect time to trigger the shutter and take the picture. It doesn't matter how much you paid for your camera gear, what brand of film you use, or what your subject is. If you miss the Kodak Moment, you've missed the picture.

ANTICIPATING THE ACTION

Some of us have a problem with timing. We see our subject at the peak of an action and decide to take a picture. However, by the time the message (take the picture) leaves our brain, travels down our arm, reaches our trigger finger, and we trigger the shutter, the action is over. Try to anticipate the action and start to trigger the shutter a fraction of a second early.

HOW FAST CAN YOU REACT

Some people have good situational awareness. They know what is happening around them and what to do in almost any situation. They are the race car drivers and fighter pilots. Most of us, however, don't react that fast.

My standard technique for speeding up reaction time is to

Mike Haber captured the "Kodak Moment" when the bristle worm came over the top of the fire coral. Nikonos IV-A, 35mm lens, 1:2 extension tube, one strobe with manual exposure control and Ektachrome 64 EPR.

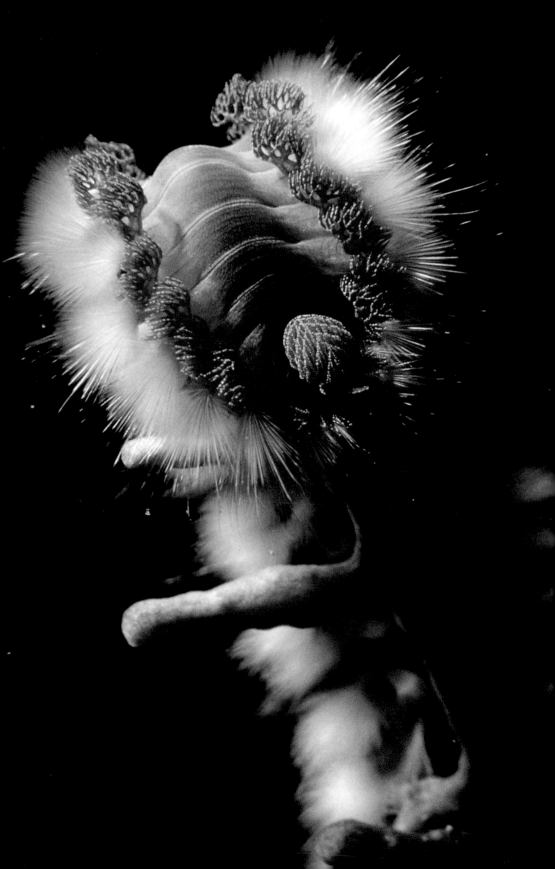

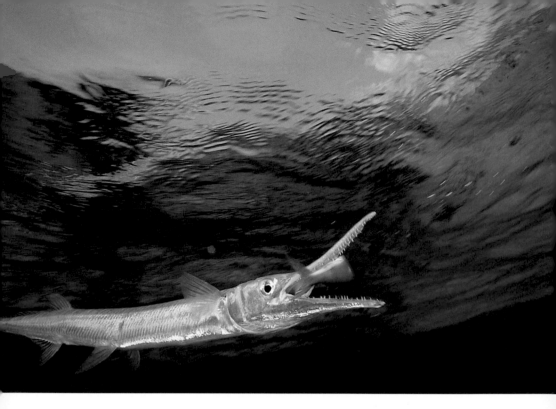

I say it was luck; Mike Haber says it was skill. Either way, Mike photographed this houndfish just as it caught its lunch. Nikonos V, 15mm lens, one strobe with manual exposure control and Ektachrome 64 EPR.

preset as many camera controls as possible ahead of time. For sunlight pictures of seals or stingrays darting by, for example, I set my Nikonos for A (automatic), f5.6 and prefocus for five feet (or whatever distance I expect to see the seals or rays). Then, I just point and shoot. Likewise, assume that you see a skittish fish resting on a coral head. You plan to photograph the fish at a distance of two feet. Preset aperture, shutter speed, strobe angle and focus before approaching the fish. If you wait until you get there and then start fussing with your camera, the fish will probably dart away before you can take its picture.

THE MACHINE GUN APPROACH

Use the *machine gun approach* for fast action. At Stingray City, Grand Cayman, for example, I tell my students to shoot 36 shots

as fast as they can. Then, swim back to the boat and hand up the camera for a reload. Most students shoot three rolls on a single tank. Out of their 108 exposures, they get some excellent shots.

● ● ● ──────────────────────────────────

If you have a housed camera with motor drive that will expose several frames per second, you can use it to photograph fast action. Start shooting before the action begins, and continue to shoot until after the action ends.

────────────────────────────────── ● ● ●

When an expert diver, such as Barbara Brundage, is handling an eel, and anxious fish are darting around, it may be difficult to anticipate the "Kodak Moment" for the best picture. In this case, I suggest the "machine gun approach." Shoot as fast as you can. Nikonos III, 15mm lens, single strobe with manual exposure control and Ektachrome 100 EPR.

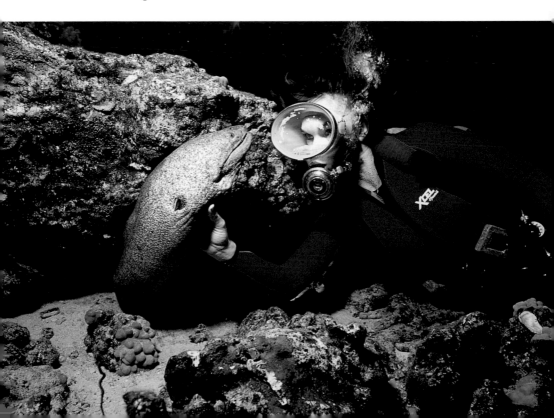

THE SNIPER APPROACH

The *sniper approach* aims for quality rather than quantity. You stalk your subject, take careful aim and WHAMO—you get the picture. The sniper approach is ideal for telephoto macro work with a 100mm or longer lens. With wider lenses, sleeping sharks are also good sniper targets. A sniper may take several pictures, bracketing with exposure, angle and focus, to get the shot he wants, but each shot is composed slowly and carefully.

●●● ——————————————————————————

Marty Snyderman and Clay Wiseman (Guide to Marine Life, Aqua Quest Publications) look for yellowhead jawfish in rubble or sand patches. Clay settles about fifteen feet from the jawfish, and approaches at about one foot per minute. He also tries to hide behind a gorgonian when he closes in with his 100mm lens.

———————————————————————————— ●●●

Mike Haber used the "sniper approach" to photograph this eel and cleaning gobi. He moved in slowly, took aim and fired. Canon F1, 50mm macro lens, two strobes with manual exposure control and Ektachrome 64 EPR.

SAVE SOME AMMO

Sometimes the best photo opportunities occur at the end of the dive, while you are swimming to or are just below the boat. For example, a friendly barracuda hovers beneath the keel and allows you to approach, but you are out of film. Save a couple frames of film for the end of the dive, and you won't be saying, "The 'cuda was there, but I was out of film."

Part
··· 3 ···
Let's Improve
The Picture

··· *10* ···

ISOLATE YOUR SUBJECT

Once you have a subject, isolate it from competing backgrounds, foregrounds and other subject matter.

WHAT IS YOUR SUBJECT

M ost viewers expect to see an identifiable subject. If the viewer has to search for the subject in your picture, they won't enjoy viewing it. Therefore, it's usually best to have a specific, identifiable subject. There are exceptions, of course, such as a portrait of a camouflaged creature or possibly an artistic montage of forms and shapes or colors.

• • •
Viewers often have short attention spans; if they don't know what or where the subject is in a picture, they stop looking.
• • •

ONE MAIN POINT OF INTEREST

The simplest way to identify your subject is to concentrate on a single subject that dominates the picture. The picture could be a close-up fish portrait, a manta ray gliding overhead, or a shark against a blue-water background. In each of these cases, the one main point of interest clearly identifies your subject.

MULTIPLE POINTS OF INTEREST

You can have multiple points of interest, such as a school of fish, or two or more divers. At Stingray City, Grand Cayman, rays

swooping around and over a diver provide multiple points of interest. Repeated patterns, such a pile of machine gun bullets at Truk Lagoon or anemone tentacles also offer multiple points of interest.

The Salad Bowl

Imagine a picture of a coral head decorated with a wealth of tiny, colorful marine life. While the overall view is pleasing, your eye searches for a dominant subject. However, you don't find any one point of interest that dominates. The picture is a "salad bowl." It shows a little of everything, but not much of anything. Most pleasing salad bowl shots have at least one dominant subject.

I found this marine life clinging to a steel cable on the sunken Sankisan Maru. *The dark, midwater background helps isolate the colorful subject. Nikonos V, 35mm lens, Nikonos Close-up Outfit, two strobes with TTL exposure control and Ektachrome 64 EPX.*

●●● ─────────────────────────────
Salad bowl shots can be valuable introductory shots in slide shows. For example, you can begin with a salad bowl shot to establish where a tiny fan worm has set up housekeeping. Or, you can end a macro sequence with a salad bowl shot to show where your macro subject lives.
─────────────────────────────── ●●●

GET LOW, GET CLOSE AND SHOOT UP

This is one of the most important techniques of underwater photographers, both still and video. By getting lower than your subject, you exchange cluttered backgrounds for non-competing, midwater backgrounds.

The multiple points of interest are obvious. The grouper's face, adorned with cleaning gobies, against a dark background, draws your attention. Nikon F4, 60mm AF Micro Nikkor lens, two strobes with TTL exposure control and Ektachrome 64 EPX.

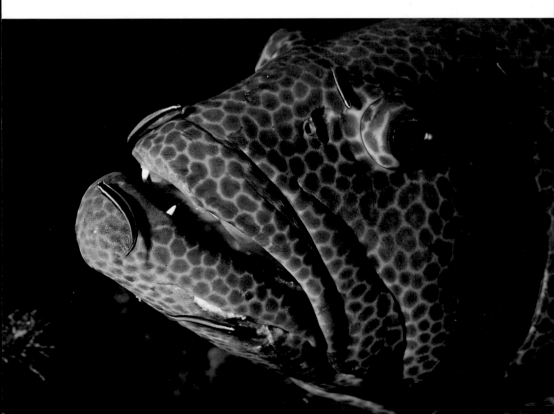

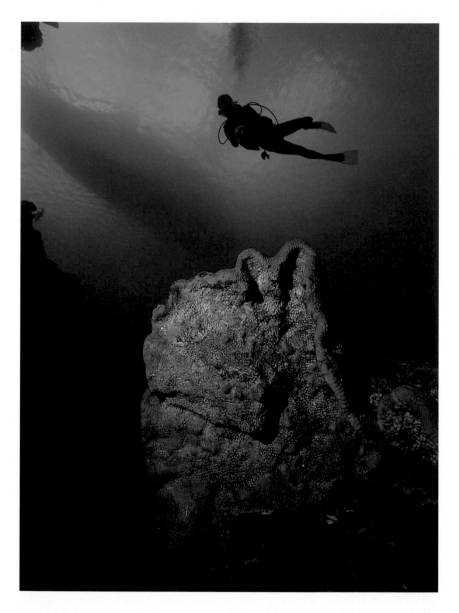

By getting low, close to the sponge and shooting up, I was able to isolate the colorful elephant ear sponge and silhouette Mike Mesgleski and the boat in the background. The aperture was set for the blue-water background, and the strobe was held at the corresponding strobe-to-subject distance from the sponge. Nikonos V, 15mm lens, single strobe with manual exposure control and Ektachrome 64 EPR.

The two coral formations, upper left and lower right (rule of thirds) are the strongest subject areas in the "salad bowl" shot. The tiny fish in the background add minor points of interest. The technique was to get low and shoot with an upward camera angle. Nikonos III, 15mm lens, single strobe with manual exposure control and Ektachrome 64 EPR.

Upward views are taken from the subordinate position and make the subject appear dominant to the viewer. An upward view of a hammerhead shark swimming overhead emphasizes the power of the shark. The viewer has a greater feeling of the shark's presence and a greater respect for its size and beauty.

● ● ● ────────────────────────────────────

Thumb through your favorite dive magazine. See how many of the normal and wide-angle shots are taken with upward camera angles.

──────────────────────────────────── ● ● ●

GET HIGH, GET FAR AND SHOOT DOWN

There will be times when you may wish to get high above your

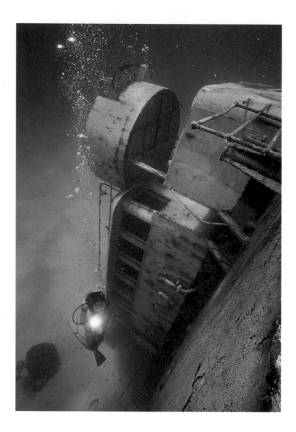

Getting high, far and shooting down requires contrast to isolate your subjects. This point of view is detached from the action; the viewer is an observer rather than a part of the picture. Cathy Church's small dive light added an accent point. Nikonos V, 15mm lens, sunlight exposure and Ektachrome 64 EPR.

subject and shoot down. You may choose downward camera angles at a wall, or when photographing the deck of sunken ship. However, if you decide to get high, get far and shoot down, you must have contrast. You need a dark subject against a light sand background, or a light subject against a dark background.

Downward views are from the dominant position and create a feeling of aloofness. Imagine the viewer sitting on a cloud, looking down and inspecting what lies below. This point of view is detached from the action; the viewer is an observer rather than a part of the picture.

··· *11* ···

PLACING YOUR
SUBJECT IN THE PICTURE

*Imagine that you are making a large pizza. You care-
fully select each tidbit and place it where it will look the
best. The same idea applies to underwater photography.
Place each part of the subject where it will look the best in
the picture.*

THE BACKGROUND IS THE STAGE

The background is the stage that provides the setting in
which you place your underwater subjects. The back-
ground shows locations, such as a wreck, reef, an eel's lair, or
simply blue water or black. To be effective, the background must
support and direct attention to your subject.

● ● ●
*Backgrounds show visibility, location and provide a stage for
your subjects. Foregrounds provide depth in the picture and often
lead the viewer's eye to the subject.*
● ● ●

AVOID COMPETITIVE BACKGROUNDS

Some backgrounds compete with your main subject. A back-
ground cluttered with corals or other divers, for example, can
draw the viewer's eye away from your beautiful angelfish. The
brightness, color, contrast, sharpness and detail should be in-
cluded in your subject, not in the background. Three non-
competitive backgrounds are sandy bottoms, and midwater blue

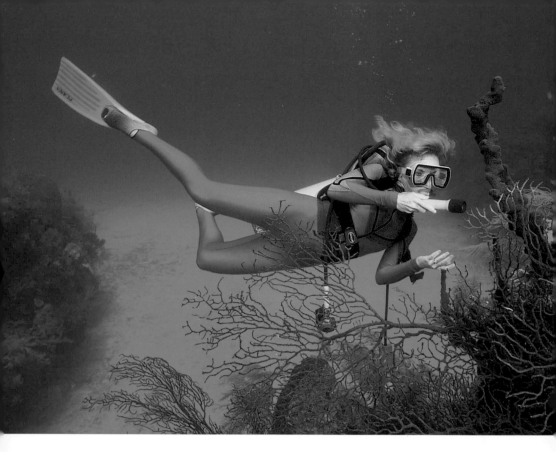

The blue-water background and coral foreground provide the setting for Andrea McCann as she explores the clear, tropical water. Nikonos V, 15mm lens, single strobe with manual exposure control, and Fujichrome 100 RD.

or black. Use these when you want to direct complete attention to your near subject.

● ● ● ──────────────────────────────

An exception to "avoid competitive backgrounds" is when a bright, colorful subject and a bright, colorful background form a pattern.

────────────────────────── ● ● ●

Play "Tic-Tac-Toe" (the rule of thirds)

Imagine tic-tac-toe lines superimposed over the picture area. These lines divide the picture into thirds, horizontally and vertically, and the four points where the lines cross are the intersections of thirds.

Composing with the *rule of thirds* means placing points of interest near one or more of these intersections of thirds. The rule of thirds is one of the most easily used and most effective rules for underwater photo composition. You see the rule of thirds in many

Although sharp, colorful background competes with the brittle star, the background and brittle star blend together to form the subject. Mike Mesgleski took this with a Nikonos V, 35mm lens, 1:2 extension tube, one strobe with manual exposure control and Fujichrome 100.

The rule of thirds can be used with subjects ranging from wide-angle scenics to portraits. This portrait of two French angelfish is a textbook example of the rule of thirds composition. Nikonos V, 28mm lens, Nikonos Close-up Outfit, two strobes with TTL exposure control and Ektachrome EPZ.

of the photographs in this and my other books. Painters have used this rule for centuries.

• • •
Round and oval subjects present an important exception to the rule of thirds. The center of the picture is often the most pleasing placement for round and oval subjects.
• • •

Place Horizons on Thirds

Horizon lines, topside or underwater, are often more pleasing when placed one-third from the top or bottom border of the picture. An angled horizon line can start at the lower intersection of thirds and continue up to the opposing upper intersection of thirds.

Moving Subjects Need a Place to Go

If a moving fish appears to be bumping his nose against the border of a picture, but has ample space behind its tail, the viewer

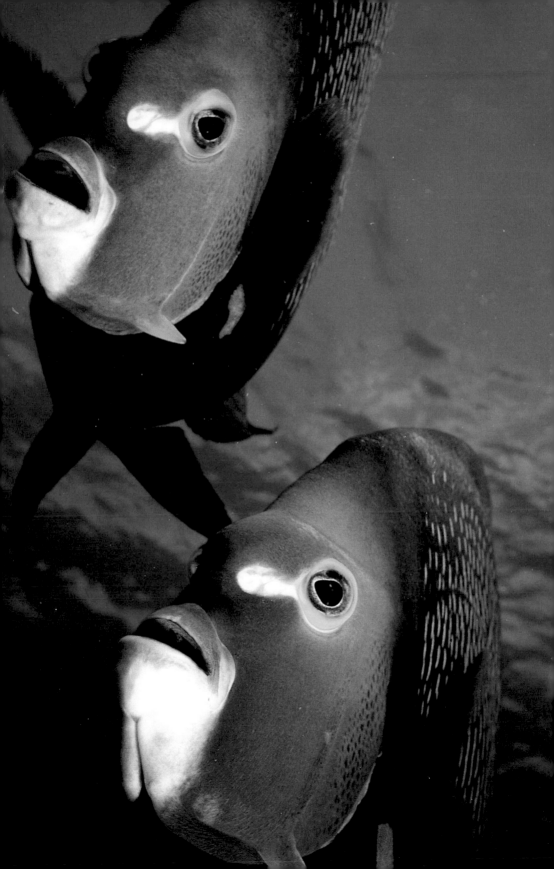

will sense that something is wrong. The picture is out of balance because moving subjects need a place to go. Try to put some empty space in front of the fish's nose even if it means amputating part of its tail.

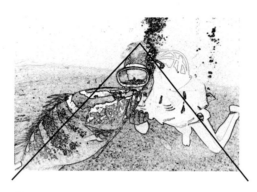

The two leading lines, created by Mike Mesgleski's body and the grouper, lead your eye to their faces. An implied line (the bottom border of the picture) completes the triangular composition. Nikonos V, 15mm lens, one strobe with manual exposure control and Fujichrome 100 RDP.

Use Leading Lines

Our eye tends to follow strong lines. Thus, we can use lines as a tool to lead the viewer's eye to our subject. Be careful, however, that leading lines don't lead the viewer's eye away from the subject or out of the picture. Strong lines create moods in pictures: vertical and horizontal lines are static; strong diagonal lines are dynamic.

Triangles and Pyramids

Sometimes leading lines and objects within a picture form a triangular shape. This can strengthen composition because the triangular arrangement gives the picture an overall shape, it "ties" subjects together. The base of the triangle gives the picture a "bottom." Triangles and pyramids also help lead the viewer's eye to the main subject because the main points of interest are often near the peak.

Parallel Lines Imply Unity

Two or more leading lines in parallel imply unity. Imagine a trumpetfish in close parallel with another fish or a soft coral. The trumpetfish seems to belong in its setting. Two divers swimming side-by-side also seem to belong together. Likewise, a diver posing in parallel with a leading line seems to belong in the picture. No action is implied; the diver appears to have been there for a while.

● ● ● ────────────────────────────────

Although parallel lines imply togetherness, parallel lines can also lead to boring pictures. To make the composition more interesting, compose so parallel lines are at slight angles.

──────────────────────────────── ● ● ●

The parallel alignment of the fish and rope implies unity, the fish seems to belong there. Notice that the rope is angled and the fish is angled slightly to the rope, making the picture more dynamic. Nikonos RS, 50mm lens, two strobes with manual exposure control and Ektachrome 64 EPX.

THE "DISCOVERY POSE"

When photographing divers, have your models cross the strongest leading line in the picture. Crossing the leading line implies action and excitement. These divers appear to have just arrived. I call this the *discovery pose.*

● ● ●
 The discovery pose implies action. It's a good technique for introductory scenes for both slide shows and videos.
 ● ● ●

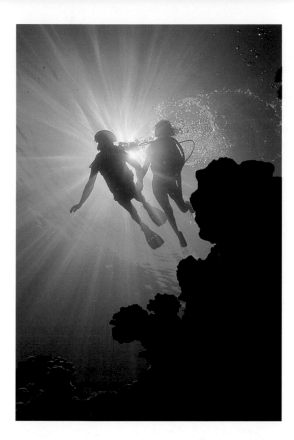

I call this the "discovery pose." By having Jeff and Teri Leichen cross the main leading line formed by the lava formation at the lower right, it appears they have just arrived. Nikonos V, 15mm lens, sunlight exposure and Ektachrome 64 EPR.

AVOID THE THREE S'S

The three S's refer to how you align your subjects and are as follows:

1. Straight up and down: Great for pillar corals and flag poles, but not so great for underwater subjects such as divers.
2. Straight across: Acceptable for densely packed schools of fish and horizon lines, but poor for most other subjects.
3. Straight on or straight away: A head-on view of a diver produces an armless blob.

While the background may be aligned vertically, horizontally or straight on or away, the main subject is usually aligned at an angle. Otherwise, in most cases, the composition is too rigid.

● ● ● ─────────────────────────────────

Avoid the three S's. Putting your subjects at angles will dramatically improve your underwater photo composition. Think: Angles, angles and angles!

───────────────────────────────── ● ● ●

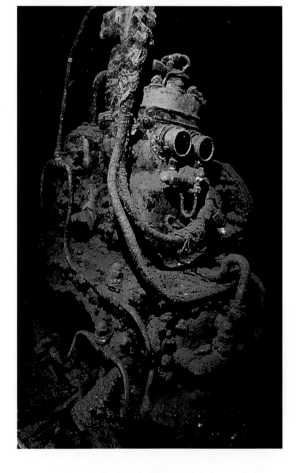

I named this air compressor "R2 D2," after the robot of Star Wars' fame. Although R2 D2 was standing upright, I tilted the camera so he would lean forward slightly. Nikonos V, 15mm lens, two strobes with TTL exposure and Ektachrome 64 EPX.

THE IMPLIED VANISHING POINT

Imagine that you are standing in the middle of a set of railroad tracks. Looking down the length of the tracks, the two rails seem to meet at a distant vanishing point. You can use an implied vanishing point to create a feeling of depth in your pictures. To create an implied vanishing point, compose so the two strong leading lines meet outside the picture area. Place your main subject in the "V" of these converging lines.

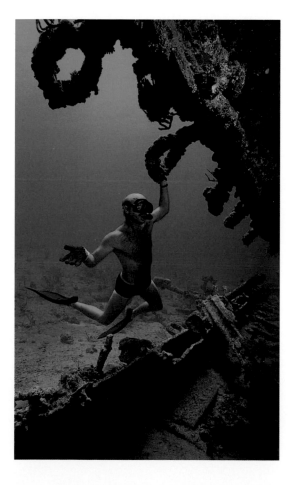

A breath-hold diver reaches the bow of the HMS Rhone, *in the BVI. We had discussed the pose before the dive so he knew exactly where to go. I placed him in the "V" of the two leading lines that met outside the picture area. Nikonos V, 15mm lens, one strobe and manual exposure control, and Ektachrome 64 EPX.*

··· *12* ···

WORKING WITH PATTERNS

You don't have to look at every detail to enjoy the beauty of a pattern. With a school of fish, for example, you can examine one or two individual fish and then enjoy the symmetry and harmony of the entire school of fish.

PATTERNS ARE EVERYWHERE

We are surrounded by patterns formed by lines, shapes and colors. The members of a uniformed marching band in a parade, a line of trees along an avenue and a school of jacks beneath a dive boat are all familiar patterns. There are moving patterns, such as moving schools of fish; there are static patterns, such a pile of machine gun bullets in the hold of a sunken ship. Our eye constantly looks for patterns and tries to create patterns in what we see.

TEXTURE PATTERNS

Think of octopus skin. Imagine the changes in texture as the octopus reacts to different bottom conditions. Think about how fast the skin changes from smooth to bumpy texture patterns. The texture patterns of sponges and corals can also form beautiful abstract photographs.

• • •

Side lighting emphasizes textures because the angled lighting falls over the little "hills and valleys" of the subject's surface. Also, the parts of the subject that are nearest to the strobe receive more light and the parts farthest from the strobe receive less light. Thus, side lighting makes the subject appear more dynamic. Front lighting (with the strobe near the camera) produces flatter, less contrasty pictures. Try varying lighting positions and choose the best lit pictures later.

• • •

REPEATED PATTERNS

A school of barracuda, nose to tail, side to side and belly to back, is a typical repeated pattern. You don't have to examine every single barracuda when you view the picture. You examine

The octopus can change the texture patterns of its skin, as well as its color, to match its surroundings. Stay with an octopus, and you will see several different renditions of the same subject. Nikonos V, 35mm lens, Nikonos Close-up Outfit, one strobe with TTL exposure control and Ektachrome 64 EPX.

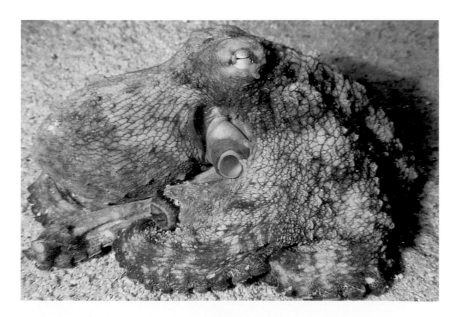

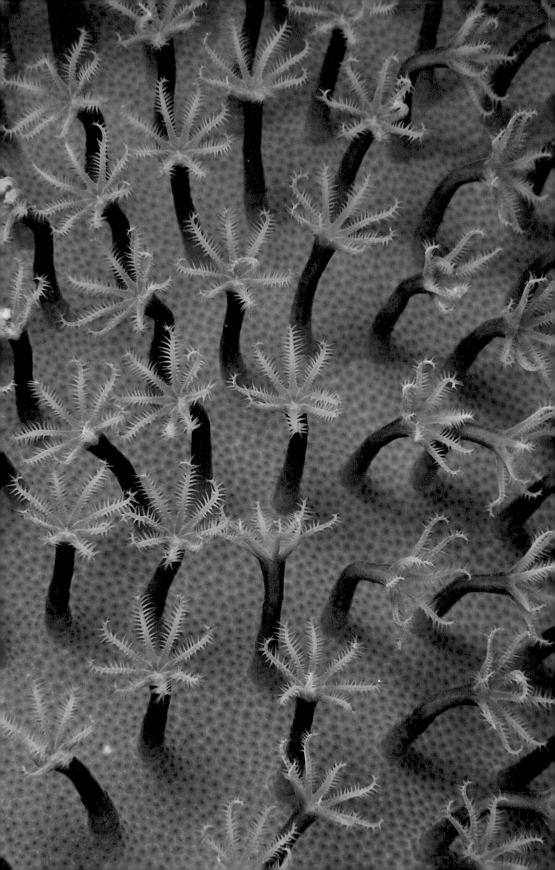

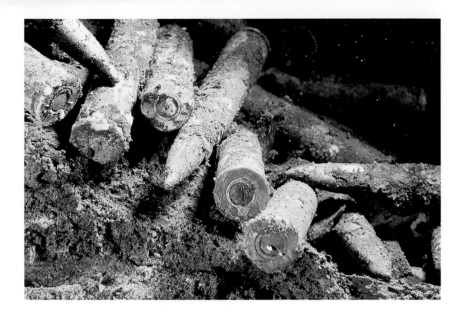

This random pattern of machine gun bullets is more pleasing to me than bullets aligned in a clip. Nikonos RS, 50mm lens, two strobes with TTL exposure control and Ektachrome 64 EPX.

one barracuda, maybe two, then you enjoy the form and shape of the overall pattern. A strong repeated pattern gives us a reassuring feeling of orderliness—things are as they should be.

THE PERFECTION OF IMPERFECT PATTERNS

While patterns can be beautiful, perfect patterns can be too static and boring. Have you ever looked at a perfect pattern, and wished you could reach in and stir things up? At Truk Lagoon, a pile of jumbled machine gun bullets (to me) forms a better

Carol Takvorian photographs tiny subjects that I can't even see. She found this lovely pattern of tiny anemones on the superstructure of the **Yamagiri Maru,** *in Truk Lagoon. Nikon N90, 105mm AF Micro Nikkor lens, one strobe with TTL exposure control and Velvia 50.*

The random pattern of orange balls on the tips of the anemone's tentacles gives me a "lost in space" feeling. The pattern of the anemone's body and tentacles provide a background pattern. Mike Haber shot this in "inner space," with a Nikonos IV-A, 35mm lens, 1:1 extension tube, one strobe with manual exposure control and Ektachrome 64 EPR.

pattern than a clip of bullets all in a row. A perfectly aligned school of fish, with one fish slightly out of alignment, would also catch my eye.

AVOID MERGERS

Avoid the four following mergers: blocking the view, the distant appendage, color on color and details on details.

1. Blocking the camera's view of the subject: This is the most obvious merger. Imagine a diver's head hidden behind a beam as the diver explores a wreck.

2. Creating a distant appendage: This often occurs when you use SLR viewfinding and focusing. When you looked at the viewfinder screen, you didn't see that distant coral formation behind your near subject. Later, in the picture, your diver will appear to have "antlers" growing on the top of her head.

3. Color on color mergers: This is a common problem for close-up photographers. Imagine that you see a beautiful yellow fan worm on a background of light orange sponge. Wow, it appears gorgeous to your eye. In a picture, however, the fan worm will blend in with the background. If you go for colorful subjects, choose non-competing backgrounds or (if possible) move the subject to another background.

4. Complicated patterns: A subject with complicated patterns or details can merge with a background that also has complicated patterns or details. Unless you want the subject and background to blend together to form the picture, choose a plain background or use depth of field to blur the background.

··· *13* ···

ADDING A
TOUCH OF GRACE

*Straight lines, angles and triangles can lead to strong,
but mechanical composition. Let's explore some techniques
for adding a touch a grace to your pictures.*

LOOK FOR CURVES

C-curves and S-curves can be combined with angles to
produce graceful composition that leads the viewer's eye
pleasantly through a picture. As examples, think of the curved
rope sponges on a Caribbean wall, the curved body of a fish or
nudibranch, or the S-curve formed by an eel's body. Female
divers often appear more graceful in photos than male divers
because their bodies have graceful curves.

LOOK FOR OVALS

Ovals are also graceful forms of composition. For example,
think of the oval body of an angelfish. Place the oval angelfish
against a natural or non-competing background, and you have a
gracefully composed picture. The oval shape of a nautilus shell is
another example of natural, graceful composition. Ovals can also
be formed by soft corals, coral crevices, openings to lava tubes

*The tiny fish's body forms a C-curve that adds a touch of grace. If the fish's
body were straight, the fish wouldn't appear as graceful. Nikon F4, 60mm
lens, two strobes with TTL exposure control and Ektachrome 64 EPX.*

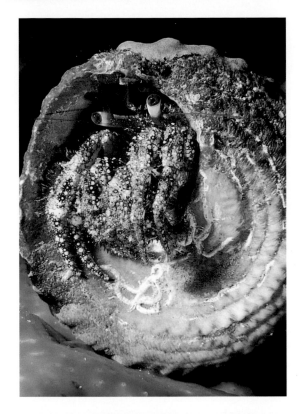

A tiny hermit crab peeks out of his home, an oval-shaped shell. Mike Mesgleski spotted this oval composition in less than a heartbeat. Nikonos V, 35mm lens, 1:1 extension tube, one strobe with manual exposure control and Ektachrome 64 EPR.

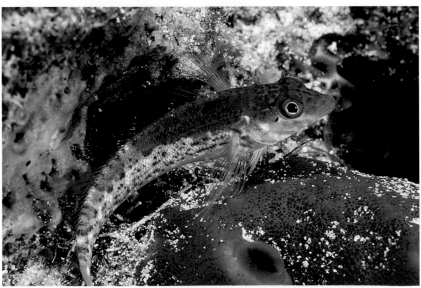

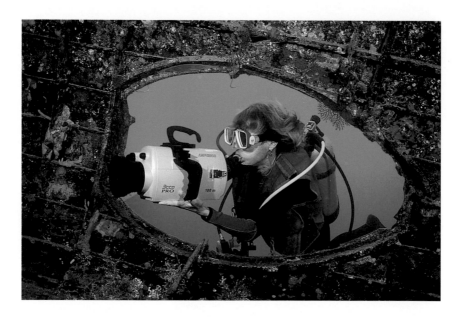

An oval opening in the Betty bomber fuselage in Truk Lagoon forms a pleasing frame for videographer Linda Kuschel. Nikonos RS, 20-35mm zoom lens, two strobes with manual exposure control and Fujichrome 100 RD.

and wreckage. Two of my favorite ovals are the teardrop-shaped observation openings in the fuselage of the Betty bomber, in Truk Lagoon.

LOOK FOR DELICATE DETAILS

The delicate tentacles of a tube worm, fan worm, anemone or yellow cup coral attracts the viewer's eye. Likewise, think of brittle stars on sponges, the details of banded coral shrimps or the delicate fins of a small fish.

The delicate details of the cup coral tentacles, the surface of the sponge, and the patterns on the fish's body are all captured in Mike Mesgleski's close-up. Canon F1, 50mm macro lens, two strobes with manual exposure control and Ektachrome 64 EPR.

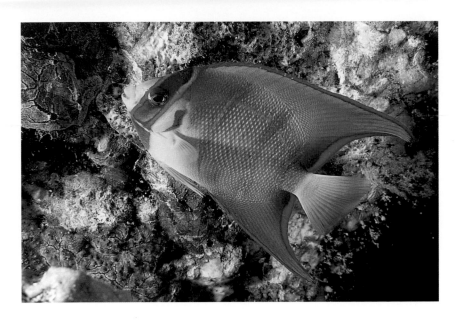

Angelfish are a collection of curves and ovals. Notice how this one's nose and tail are angled for rule-of-thirds composition. Nikonos RS, 50mm lens, twin strobes with TTL exposure control and Ektachrome 64 EPX.

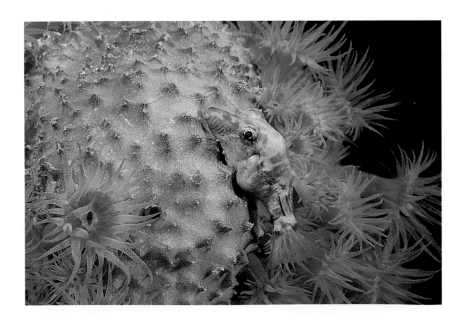

LEFT-TO-RIGHT EYE TRAVEL

Because most of us read from left to right, our eyes favor left-to-right eye travel. Thus, if a picture's color, brightness and main points of interest draw our eye from left to right, the picture is comfortable to viewers. However, if our eye is pulled from right to left, we feel that something is wrong. We don't know what is wrong, but the picture just isn't comfortable to view.

● ● ● ─────────────────────────────

Find an underwater picture that you like—one that seems to have left-to-right eye travel. Then, hold the picture up to a mirror and see if it loses any of its appeal. (Hey, you might like it better that way!)

───────────────────────────── ● ● ●

Our eye follows Mike Haber's left-to-right line of sight as he prepares to photograph the engine room telegraph on the bridge of the Shinkoku, *in Truk Lagoon. Nikonos V, 15mm lens, two strobes with manual exposure control and Fujichrome 100.*

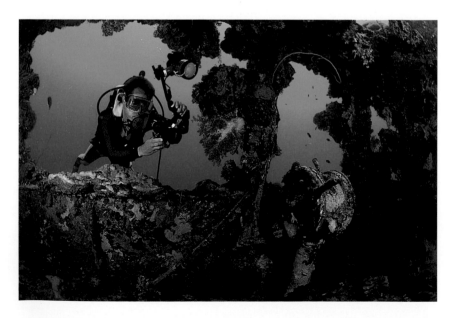

CHECK THE BALANCE

Think of your subjects as people sitting on a teeter-totter. If the teeter-totter is to function, you need balance. You need one or more people on each end. Likewise, if all the color, brightness and main points of interest are on one side of a picture, the other side appears empty and wasted. Yes, moving subjects need a place to go, but most pleasing pictures have good balance.

● ● ●
Imagine a picture hanging on the wall. If the subject is too one-sided in the picture, you almost expect the picture to tilt to that side.
● ● ●

FRAMING YOUR SUBJECTS

You can sometimes enhance your subject by framing it with the foreground or background. As examples, you can frame divers with a circular swirl of tiny fish, gaps in corals or sponges, tunnel entrances, crevices, or hatchways in sunken vessels.

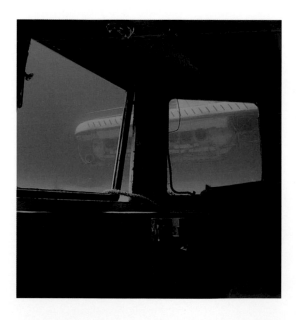

We're hiding inside the wheelhouse of a small, sunken tug boat and watching the Atlantis Submarine glide by. We are "the hidden viewer." In this situation, take several shots to vary the size of the windows in the foreground. Nikonos V, 15mm lens, sunlight exposure control with manual exposure control (aimed out window) and Ektachrome 64 EPR.

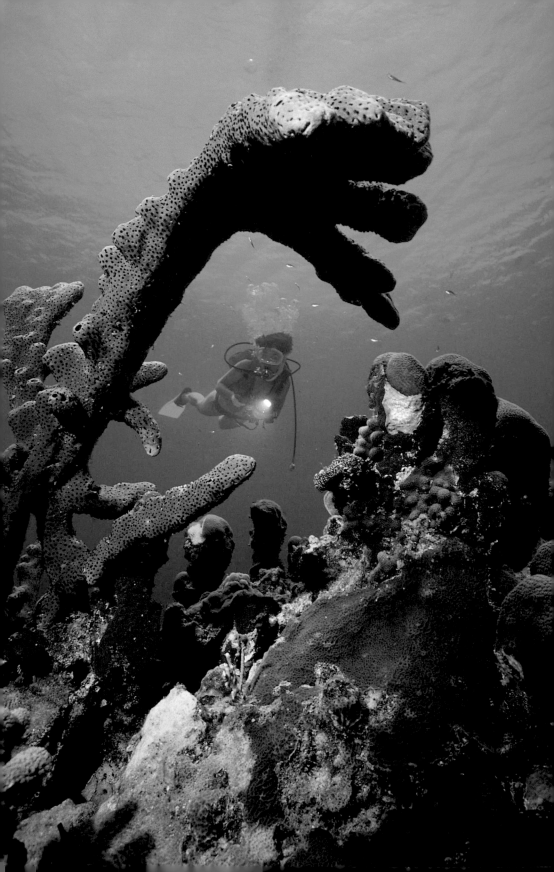

If the frame is near, bright and colorful, and the far subject is beyond the range of your strobe, focus for the frame and use the strobe to illuminate the frame. Let sunlight illuminate the distant subject. If the near frame is drab, use artificial light sparingly or not at all and focus for the distant subject.

VERTICAL OR HORIZONTAL

The vertical format is often used for portraits, and the horizontal format for group shots of divers or marine life. Magazine covers and some brochure shots are usually composed vertically; the interior pictures are often horizontal or square. If there is any doubt as to which format to use, shoot both ways. You can always decide which is best later.

● ● ● ————————————————————————
Pictures for magazines, newsletters and brochures often use vertically-composed pictures with space above and below the subject for text.
——————————————————————————————— ● ● ●

I used sponge and coral formations to frame the distant diver. Nikonos V, 15mm lens, one strobe manual with manual exposure control and Ektachrome 64 EPR.

··· *14* ···

SPECIAL
LIGHTING EFFECTS

*I've included the following techniques just to stimulate
your imagination. You can start with these ideas and then
expand on them to develop your own creative techniques.*

AIR POCKET REFLECTIONS

Shooting reflections is not only fun, but you can get some
pleasing pictures. The idea is to show both your subject and
your subject's mirror image in the same picture.

Diver's bubbles sometimes form air pockets in the overheads
of wrecks and the ceilings of caves. Undisturbed, these air pockets
have smooth surfaces that reflect mirror images. Both you and
your model must be extremely careful not to exhale under the air
pocket while taking pictures. Otherwise, your bubbles will dis-
turb the air pocket.

Move in slowly and aim your strobe downward at your subject.
If the beam of light from the strobe strikes the airpocket's surface,
you won't see the reflection.

The overhead of the sunken Cartanser Sr., *in U.S. Virgin Islands, had a
large air pocket in the galley overhead. Cathy Church, with her strobe set for
low power and slave mode, entered from the starboard side. I entered from
the port side to take the picture. Nikonos III, single strobe with manual
exposure control and Fujichrome 100.*

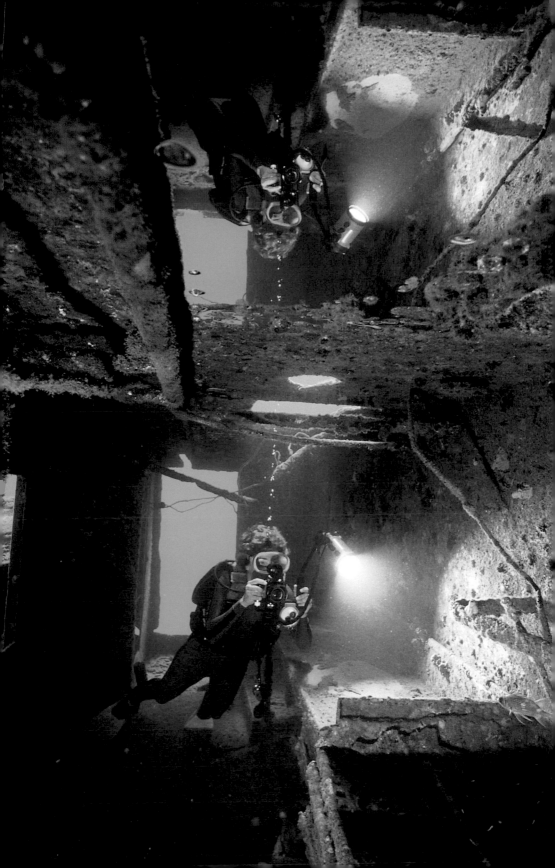

*This arrow crab was
photographed against
a backlit color panel.
A slave strobe was
held behind the color
panel. Nikonos III,
35mm lens, 1:3
extension tube, two
strobes for front and
back lighting,
Ektachrome 64 (circa,
1979).*

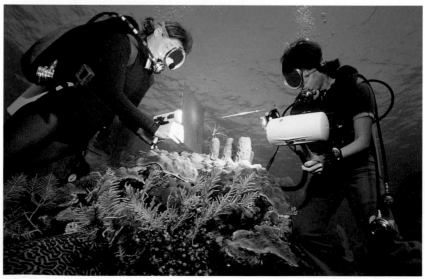

Color Panels with Backlighting

The goal is to have bright, colorful backgrounds behind close-up subjects. You will need two strobes and a translucent, plastic panel. Try a panel that is about 1/8-inch to 3/16-inch thick.

1. Find a close-up subject away from obstructions so you can place the panel about three to eight inches behind the subject. It should be far enough away so blemishes or scratches won't be in focus.
2. Place the rear strobe behind the panel, about four to six inches away for extension tube shots, and about twelve inches away if you are using a close-up lens. Aim the strobe at an angle so the strobe's reflector won't create a hot spot in the picture.
3. Aim the main strobe at the subject, using your standard aperture setting. Aim at an angle of about 45 degrees to avoid reflections on the panel, and take the picture.

● ● ● ────────────────────────────────

This technique will take practice. Reflections and hot spots will ruin some pictures as you learn. Shoot a bunch.

──────────────────────────── ● ● ●

Color Panels with Frontlighting

You can also use color panels with front lighting. Aim one strobe at the close-up subject and the other at the front of the color panel. By angling the panel, some colored light will reflect back to the subject to create a hint of color.

Bonnie Charles (left) and Cathy Church (right) demonstrate backlighting with a color panel. Bonnie's strobe had a slave sensor that flashed when it detected the light from Cathy's strobe. I used a Nikonos III, 15mm lens, single strobe with manual exposure control and Ektachrome 64 (circa, 1979).

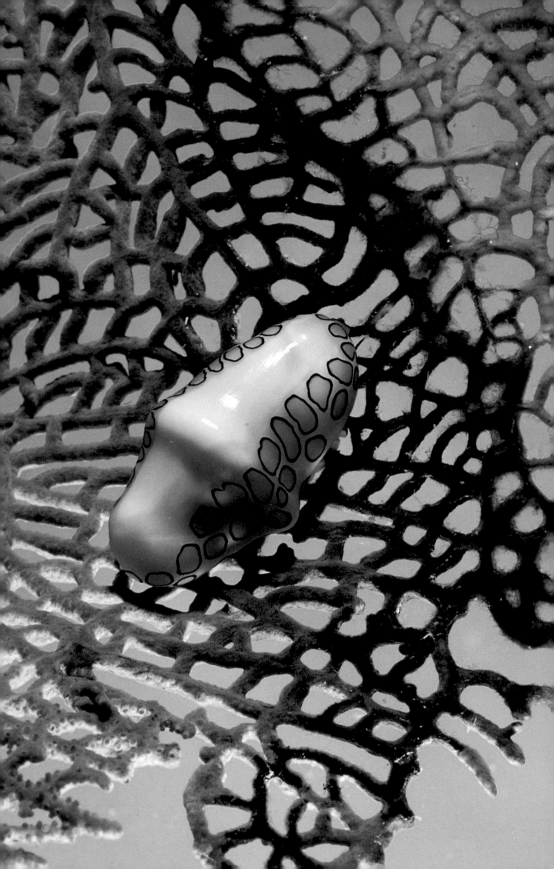

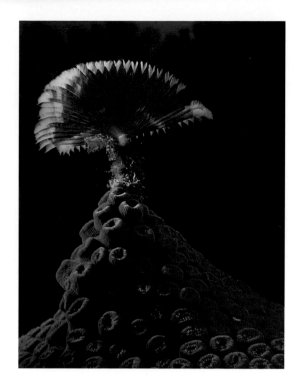

The left strobe had green acetate over the reflector; the right strobe had red. Nikonos III, 35mm lens, 1:3 extension tube, two strobes with manual exposure control and Ektachrome 200.

FILTERED FLASH

This is a close-up lighting technique for frilly or ridged subjects. Attach a few layers of colored acetate over the reflectors of two strobes. In my experiments, I used red and green. Use extreme side lighting so the red strobe illuminates one side of the subject, and the green strobe illuminates the other side. The red and green produce yellow where the strobe beams overlap.

Mike Haber and Mike Mesgleski worked together for this shot. Mike Mesgleski handled the camera and strobes; Mike Haber held both the colored panel and the second strobe in place. The right strobe was positioned low and aimed up at an angle to light the colored panel as well as rim light the back of the sea fan. The left strobe was positioned high and aimed down from the upper left, at the flamingo tongue. Mike Mesgleski bracketed exposures to allow for the flamingo tongue's reflective shell. Canon F1, 50mm macro lens, two strobes with manual exposure control and Ektachrome E-100S film.

Because the acetates block part of the light, you may need to use ISO 200 with the apertures you would normally use with ISO 64.

● ● ● ——————————————————————————————
As with color panels, using filtered flash will take some experimentation to determine the amount of filtration and appropriate film speed to use.
——————————————————————————————— ● ● ●

BACKLIGHTING

Backlighting means placing a strobe behind a subject to outline it, or to send light back to the camera through translucent parts of the subject. The pitfall to avoid is to keep the beam of the strobe from striking the camera lens directly and causing flare. Backlighting can be combined with frontlighting with frilly, translucent subjects.

This banded coral shrimp was perched on top of a piece of metal at the Balboa, *Grand Cayman. I held a single strobe behind the metal and below the shrimp. Cathy Church took the picture with a Nikonos III, Hydro Photo #2 close-up lens and Ektachrome 64.*

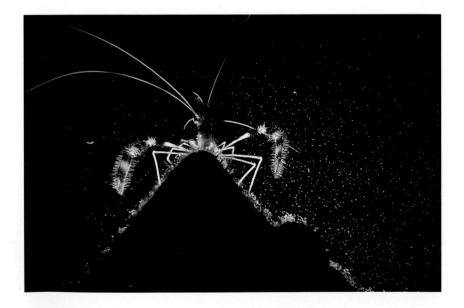

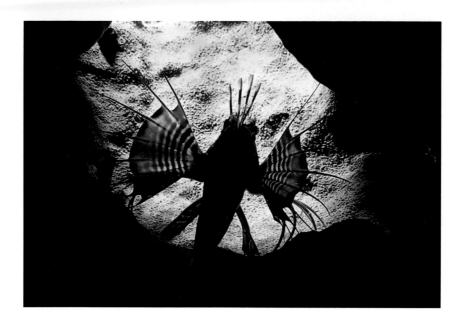

The lionfish was inside a small coral archway. I aimed the single strobe from the far side of the arch, just in front of the lionfish. Cathy Church took the picture from the near side. Our goal was to silhouette the lionfish against the background and have light pass through its fins. Nikonos III, 35mm lens, Proxilens close-up attachment, manual exposure control and Ektachrome 64 (circa, 1969).

BACKGROUND LIGHTING

Background lighting is related to backlighting. The goal of background lighting is to show a close-up subject silhouetted against its background. Select a subject that has a colorful background and aim the strobe at the background, behind the subject. Your biggest problem will be finding subjects with suitable backgrounds.

MULTIPLE EXPOSURES

The goal is to make several strobe exposures on a single frame

of film. Because ambient light could ruin the picture, this is a night photography technique.

If you want precise results, proceed as follows:

1. Mount the camera on an inexpensive tripod. Attach two-pound weights to the legs.
2. Set the shutter speed for B (bulb).
3. Hold the shutter release so the shutter is open.
4. Have an assistant flash a strobe at various locations, at a pre-determined strobe-to-subject distance. This distance will determine the aperture.
5. Close the shutter after the flashes.

It was nighttime, and we were at the "Roman columns," upright metal ribs (which are no longer upright) of the Balboa, Grand Cayman. *I placed a Nikonos III on a tripod, set the shutter speed for B (bulb) and held the shutter release in with a small C-clamp. Cathy Church went to each pillar, hid the strobe behind the pillar and used an empty camera to flash her hidden strobe. We based the exposure on the pre-planned strobe-to-subject distance. Nikonos III, 15mm lens and Ektachrome 100 (circa, 1980).*

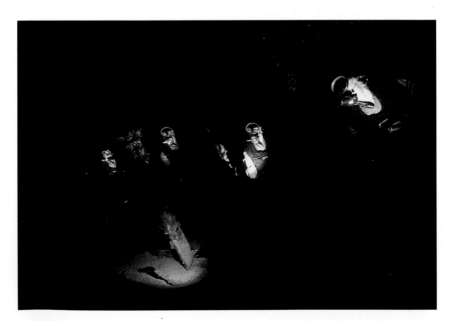

For this "photographer at work" shot, Cathy Church's (the model) two SB-102 strobes were set for slave mode and 1/16 power. Her strobes are angled away from the camera to prevent flare. Nikonos V, 15mm lens, single strobe with manual exposure control and Ektachrome 100 EPN.

The Photographer at Work

To shoot a "photographer at work" shot, which shows the photographer's strobe flashing, set the model's strobe for the slave mode. (When the slave sensor detects the burst of light from your strobe, it triggers the model's strobe.)

1. Set the model's strobe for low power.
2. Use your strobe exposure table to determine the minimum strobe-to-subject distance for your model's strobe. To do so, determine the aperture you will use, and look at the exposure table to see the appropriate strobe-to-subject distance. The model's strobe cannot be held closer than the tabled distance.
3. Avoid having the model's strobe aimed toward your camera, unless you wish to show a bright burst of light.

PART
... *4* ...

APPENDICES

···*A*···

CHOOSING A CAMERA

Choosing an underwater camera for another person is somewhat akin to choosing their hat, tie or purse. Different photographers have different needs, misconceptions and finances.

HOUSING A 35MM SLR

Housing a topside camera for underwater photography is a common option. Not only will you have a quality camera for topside shots, but a quality camera for underwater use as well. Housed 35mm SLR (single-lens reflex) cameras with 100mm and longer lenses are often used by professionals for fish photography.

Before deciding to house an expensive SLR camera in an expensive underwater housing, consider the following points:

1. Will you be able to see the viewfinder screen when the camera is in the housing and your face is behind a mask? Some 35mm cameras, such as the Nikon f4 and f5, have oversized accessory viewfinders that are easy to see. If the camera has a normal-sized viewfinder, does the housing manufacturer provide a magnifier to enlarge the viewfinder image?
2. Must you take your hands off the handle (especially your right hand, which controls the shutter release) to make aperture, focus and other adjustments?
3. How easy—or difficult—will it be to change film, lenses and lens ports when the camera is housed?
4. Can you easily remove the camera from the housing—and reinstall it in the housing—for topside shots?

5. If you are a traveling underwater photographer, consider the size and weight of the entire system—camera, housing and strobes.

AMPHIBIOUS CAMERAS

Amphibious cameras include the Nikonos RS (reflex-system) SLR camera, various models of the Nikonos camera, cameras by Sea&Sea, and simple "point and shoot" cameras by other manufacturers. Some important advantages of amphibious cameras are that:

1. You are spared the added expense and complexity of having a camera inside a separate housing.
2. Lens changes are easier and faster.
3. Add-on wide-angle adapters and close-up lenses can often be installed or removed underwater.
4. The size and weight of an amphibious system is often less than that of a housed system.

As for disadvantages:

1. Amphibious cameras are often not as adaptable to topside photography as housed cameras.
2. Most amphibious cameras lack SLR viewfinding and focusing.

··· *B* ···

DISTANCE
AND FOCUSING

*Distance and focus work hand in hand. When the lens
is set for the correct camera-to-subject distance, the picture
will be in focus—the image will appear sharp in the
viewfinder and should be sharp on film or in digital
memory.*

VIEWFINDER CAMERAS

The main purpose of the viewfinder of a *viewfinder camera* is
to aim the camera. Although exposure information may be
shown in the viewfinder, no focusing aids other than parallax
markings for minimum distance and infinity are shown in the
viewfinder. You must estimate camera-to-subject distance and
set the lens manually.

Here are some ways you can estimate distances underwater:

1. For portraits, the photographer and model can extend
 their arms and touch fingertip to fingertip to estimate
 three apparent feet. (Remember to put your arms down
 before taking the picture.)
2. For a distance of approximately 1.5 apparent feet, you
 should be able to reach about halfway to your subject.
3. At about two apparent feet, your subject will be just
 beyond your fingertips.
4. At about 1.25 apparent feet, you should be able to reach
 the subject with your fingertips.
5. Some photographers carry a thin rod marked in apparent
 feet for measuring camera-to-subject distances.
6. For close-ups, framers and probes are usually used.

SLR Cameras

In bright, clear water, SLR viewfinding is ideal. You look into the viewfinder and watch the image sharpen as you focus manually or let the autofocus system do the work. In dark, turbid water, however, SLR focusing can be difficult. If autofocus (or your eye if manual focusing) can't see contrast, focusing is virtually impossible. Some specific focusing techniques are:

1. At night, shine a light at your subject to provide light for focusing.
2. In low-contrast or dim situations, try *substitute focusing*. For example, it's difficult to focus (auto or manual) moving sharks at Blue Corner, Palau. To substitute focus, select a stationary subject (such as a diver or coral head) that approximates the distance at which you wish to photograph the sharks. Focus for this substitute subject and then aim the camera at the sharks.
3. Use manual focus rather than autofocus if the autofocus is having trouble locking onto your subject.
4. For macro subjects, focus for the approximate camera-to-subject distance, then move the camera forward and backward until you see correct focus in the viewfinder.

Flat and Dome Housing Lens Ports

Flat ports are usually used with close-focusing lenses having focal lengths of about 50mm or longer. The camera lens focuses on the image you see in the viewfinder, at its apparent underwater distance.

Dome ports are usually used with wide-angle lenses. Because the dome port acts as a lens, the camera lens focuses on a *virtual image*. This virtual image appears at a distance of about twice the diameter of the dome port (although the subject may be several feet away). With a 6-inch diameter port, for example, the virtual image is about 12 inches away. Thus, the camera lens must focus

at close-up distances or a supplementary close-up lens must be placed over the camera lens.

Some underwater photographers complain about loss of corner sharpness with wide-angle lenses and dome ports. Two possible reasons for soft corners are:

1. The relative positions of the lens's nodal point and dome port are incorrect. (Make sure the dome port you purchase matches the wide-angle lens you intend to use.)
2. The virtual image curves inward at the corners. Because the lens focuses on the center of the image, the corners may not be included in the depth of field at wide apertures.

···C···

USEFUL ADDRESSES

(E: = E-MAIL ADDRESS)
AB Sea Photo
(Equipment, rentals)
9136 S. Sepulveda Blvd.
Los Angeles, CA 90045-4804
(310) 645-8992
Fax: (860) 645-3645

Aggressor Fleet, Ltd.
(Jim Church Photo Trips)
PO Drawer K
Morgan City, LA 70381
(800) 348-2628
Fax: (504) 384-0817
http://www.aggressor.com
E: diveboat@aol.com

B&H Photo Video
(Equipment)
420 9th Ave.
New York, NY 10001
(800) 947-7008 (Orders)
(212) 444-6649
Fax: (800) 947-7008 (Orders)
Fax: (212) 239-7770
http://www.bhphotovideo.com

Blue Water Imaging
(Color prints from slides)
4930 Maple Ave.
Dallas, TX 75235
Fax: (214) 526-8103
E: bluwater@mindspring.com

Camera Tech
(Nikonos repairs, rentals, sales)
2308 Taraval at 33rd Ave.
San Francisco, CA 94116
(415) 387-1700
http://www.cameratech.com
E: info@cameratech.com

Helix
(Equipment)
310 S. Racine St.
Chicago, IL 60607
(800) 33-HELIX
http://www.mastermall.com/helix
E: helix4uw@aol.com

Jim Church
6744 Crooked Palm Terrace
Miami Lakes, FL 33014
(305) 824-1833
Fax: (305) 819-1807
http://home.earthlink.net/
 ~jimchurch
E: jimchurch@earthlink.net

Ikelite Underwater Systems
(Strobes, housings)
50 W. 33rd St.
Indianapolis, IN 46208
(317) 923-4523
http://www.ikelite.com

Marine Camera Dist.
(Photo accessories & housings)
11717 Sorrento Valley Rd.
San Diego, CA 92121
(619) 481-0604
Fax: (619) 481-6499
http://www.marinecamera.com
E: mcd2000@
 marinecamera.com

Mike Mesgleski
(Nikonos repairs, video and book on first aid for flooded Nikonos V)
10044 SW 221 St.
Miami, FL 33190
Ph/Fax: (305) 234-0903
http://home.earthlink.net/
 ~mmesgleski
E: mmesgleski@earthlink.net

Nikon Repair Facility
19601 Hamilton Ave.
Torrance, CA 90502-1309
(800) 645-6678 (repair)
(800) 645-6687 (technical)

Pacific Camera
(Nikonos repairs, leak detector)
2980 McClintock #H
Costa Mesa, CA 92626
(714) 642-7800

Sekonic (Div. of Mamiya)
(Sekonic L-164C Marine Meter II, flash meters)
http://www.Sekonic.com
E: web@sekonic.com

**Southern Nikonos Service
 Center, Inc.**
(Nikonos & Aquatica housing repairs)
9459 Kempwood
Houston, TX 77080
(713) 462-5436
Fax: (713) 462-5449

Ultralight Control Systems
(Strobe arms)
3304 Ketch Ave.
Oxnard, CA 93035
(800) 635-5511 (Order line)
(805) 984-9104
Fax: (805) 984-3008
http://www.ulcs.com
E: ulcs@ulcs.aol.com

Underwater Photo-Tech
(Nikonos & Aquatica housing repairs)
16 Manning St. #104
Derry, NH 03038
(603) 432-1997
Fax: (603) 432-4702

··· D ···

SELECTED REFERENCES

Choosing and Using Underwater Strobes, Jim and Cathy Church, Available from Aqua Quest Publications, PO Box 700, Locust Valley, NY 11560-0700. No ISBN.

Guide to Marine Life: Caribbean, Bahamas, Florida, Marty Snyderman and Clay Wiseman, Aqua Quest Publications, PO Box 700, Locust Valley, NY 11560-0700. ISBN: 1-881652-06-8.

How to Compose Better Photos, Exec. Editor Carl Shipman, HP Books, PO Box 5367, Tucson, AZ 85703. ISBN: 0-89586-111-9.

Jim Church's Essential Guide to Nikonos Systems, Jim Church, Aqua Quest Publications, PO Box 700, Locust Valley, NY 11560-0700. ISBN: 1-881652-04-1. (Also available in German from Laterna Magica.)

Jim Church's Essential Guide to Underwater Video, Jim Church, Aqua Quest Publications, PO Box 700, Locust Valley, NY 11560-0700. ISBN: 0-9623389-8-2.

Underwater Photography, Charles Seaborn. Available from Aqua Quest Publications, PO Box 700, Locust Valley, NY 11560-0700. ISBN: 0-8174633-6-4.

Learning to See Creatively, Brian F. Peterson, Amphoto, 1515 Broadway, New York, NY 10036. ISBN: 0-8174-4176-X; ISBN: 0-8174-4177-8 (paper).

Mastering Underwater Photography, Carl Roessler. Available from Aqua Quest Publications, PO Box 700, Locust Valley, NY 11560-0700. ISBN: 0-688-03881-6.

··· INDEX ···

A **bold** faced page number denotes a picture caption.